MEN'S
LACROSSE
IN MARYLAND

MEN'S LACROSSE IN MARYLAND

THE PRIDE OF THE OLD LINE STATE

TOM FLYNN

FOREWORD BY JOE FINN

THE
History
PRESS

Published by The History Press
Charleston, SC
www.historypress.net

First published 2016

Manufactured in the United States

ISBN 978.1.62619.823.4

Library of Congress Control Number: 2015953419

CONTENTS

CONTENTS

FOREWORD

G rowing up in the Baltimore area, lacrosse has always been a major interest for me. I went to a small high school where lacrosse was our major sport. I also went to the University of Maryland, a longtime lacrosse power. While the origins of lacrosse were with the Native Americans, Maryland and Baltimore in particular are some of the main reasons that lacrosse has become as popular as it has and why it is the fastest-growing sport in this country.

Johns Hopkins established the sport on campus in the late nineteenth century, and while it wasn't the first college to pick it up, it took it seriously. Lacrosse is its major sport, and its homecoming is during the lacrosse season. In the early twentieth century and beyond, the Baltimore newspapers gave lacrosse the type of coverage that most newspapers give football and baseball. For the longest time, Baltimore was one of the few areas in the country where lacrosse was played extensively at the high school level.

While Baltimore was instrumental in the growth and popularity of lacrosse, it is also important to note that lacrosse got a major boost in the United States in Brooklyn, New York. John Flannery brought the game from Canada when his job transferred him to Brooklyn. During the early part of the twentieth century, several high schools in Brooklyn fielded programs that sent many outstanding players to the college ranks. One of the oldest and biggest hotbeds for lacrosse is Long Island, and lacrosse got to Long Island by way of Brooklyn.

FOREWORD

Lacrosse continues to grow. It is no longer concentrated in the Northeast. It is played at the high school and youth level throughout the country. And it continues to grow worldwide. Not too long ago, only four countries played it. Now there are more than fifty countries playing the sport.

—JOE FINN
Archivist, National Lacrosse Hall of Fame

ACKNOWLEDGEMENTS

Many people have contributed to this book, so any acknowledgement will lack the measure of the supporting group. I interviewed dozens of players, coaches and administrators, and for the most part their contributions are represented in the main part of the book. Still, I will name a few here who may or may not appear in the text.

Let me start with former lacrosse player and current coach Matt Moore. Matt played at Washington College until sidelined by an injury, and he is an active leader in Howard County youth lacrosse. He shed valuable light on the subtleties of the sport and, just as importantly, modeled all the attributes of a great coach and instructor—encouragement, motivation and knowledge—when my son was just learning the game.

My former boss, Pat Greene, was a stalwart midfielder for the Navy Midshipmen in the early 1980s. Pat patiently shared his knowledge with me of the game's nuances and changes, as well as some great stories, while we sat in the bleachers at Hood College watching Team Maryland's club team practice on a spotless fall day in 2014.

Another early 1980s Pat with an Irish last name, Pat Tierney, provided his recollections as a former player and alum of finally seeing his Loyola Greyhounds win the national championship.

I had one of the most enjoyable conversations in compiling this book while having lunch with Hall of Famer Dick Watts. Dick has been a major shaping force in Maryland lacrosse and beyond in the past fifty years. It was a pleasure to spend time with a man of his character.

ACKNOWLEDGEMENTS

A big thanks goes to Steve Levy at UMBC, the associate athletic director/ communications, for his thorough synopsis of the Retrievers' more than forty-year history. Nairem Moran of St. Mary's College gave me a great summary of the earliest days of St. Mary's men's lacrosse program. Phil Ticknor at Washington College was another consistent source of invaluable information, as was Josh LaVeck at Salisbury.

Hats off to Ernie Larossa at Hopkins, who allowed me access to photos and information unavailable elsewhere. He is a walking history book. Navy's Stacie Michaud was a tremendous help, and the Naval Academy deserves a special tip of the cap for diligence in its historical recordkeeping. Stacie continues to do an exceptional job with the Mids' game day program, which could stand squarely on its own merits on any lacrosse bookshelf.

Loyola's Ryan Eigenbrode never fails to come through with Greyhounds material, nor does Ryan Sakamoto at Georgetown when it comes to his Hoyas. Thank you, both.

I had a great conversation with Glenn Graham, one of the top varsity sports reporters at the *Baltimore Sun,* and also Matt Owings, who has a knowledge of the game of lacrosse beyond his years. Matt did a stellar job with regular reporting of Howard County high school lacrosse in the fall of 2014.

I referred to Edward Lee's *Baltimore Sun Lacrosse Insider* regularly and, on many occasions, found Mike Preston's byline above the definitive narrative of a great game in Maryland's lacrosse history. It's fair to say that there's not another daily in the country that does a better job with lacrosse than the *Sun.*

For research assistance, Joe Finn of the Lacrosse Museum and National Hall of Fame in Baltimore was exceptional and generously contributed the foreword to the book. He's a true gentleman and a scholar of the sport and is the most knowledgeable person I've met on the sport's history. Thank you, Joe.

Without the museum, which traces its roots back to the late 1950s and a location in Johns Hopkins's Newton White Athletic Center, there would be no book. It is a bottomless source of information on the sport and a must-see for any true fan of the game. In May 2016, it is relocating from its present home just to the east of Homewood Field to a new multimillion-dollar complex in nearby Sparks, Maryland. Jodie Martin was also a big help to me at the Hall of Fame and kept me abreast of developments as the new museum and accompanying facility were being constructed in Sparks.

Ryan Horanburg of FCA Lacrosse always had a quick, informed reply to any questions.

ACKNOWLEDGEMENTS

A tip of the helmet goes to Tom Prior of Ireland Lacrosse and Will McMinn, the head coach at North Carolina's Montreat College. Although beyond Maryland state lines, both shared with me their valuable insights into the game and how a program is built just as I was filling out this book. Their players benefit greatly from their respective coaching abilities, direction and knowledge of the game.

Courtney provided my greatest support throughout the book. She also spun much-appreciated yarns about her time playing lacrosse in its frontier days at Clemson in the 1990s. Thank you, CW.

As always, a thank-you to my three sons—Charlie, Neal and Jack—each of whom gave me the distinct pleasure of watching them exhibit hard work, talent and sportsmanship on their respective playing fields.

AUTHOR'S NOTES

This book is a look at the history of men's lacrosse in Maryland. The women's tradition is equally exciting; the University of Maryland's women's team captured its thirteenth overall NCAA national championship in 2015—the second in a row. Ellicott City native and University of Maryland junior Taylor Cummings soon after won her second straight Tewaaraton Award, given to the game's most outstanding player.

I've not experienced enough of the women's game to write with the detail and insight that it merits. My hope is that this book will inspire a companion volume exploring the great tradition and history of women's lacrosse in the state.

On the men's side, it's necessary to point out there are sometimes wide variations in recorded lacrosse history. With that in mind, there will be some facts in this book that have contradictory support as to time, place and outcome (although thankfully not often on the last point). In those cases, I've selected what the research would suggest is the most probable circumstance. In other instances, the records simply do not exist.

Lastly, chapters such as the one on Johns Hopkins could readily be filled by a long list of records, scores and honors. It could, in effect, read more like an almanac than an enjoyable history. For that reason, I've done my best to balance readability with historical records. It is apt to say that the number of players who have played lacrosse with distinction in Maryland grows every day. A number, but not nearly all,

are mentioned in these pages. Thousands more could be, and if future editions should ensue, many more will, as the long history of Maryland lacrosse is perpetually unfolding.

On to the game.

INTRODUCTION

My very first decade was spent living in Belleville, a northern New Jersey suburb of New York City, as well as Newark, nearer at hand. In mid-1970s New Jersey, lacrosse had a foothold in only a few towns and prep schools, and Belleville was not one. Baseball was king of the spring sports in town, and there was no queen. I don't recall hearing the sport mentioned while living there and am fairly certain I didn't know it existed.

On November 21, 1977, I bolted out of the front door of St. Mary's School in nearby Nutley, one in a teeming pack of sixth graders eager to be out from under the vigilant watch of the school's nuns. I spotted our aqua blue Dodge Polara station wagon idling outside at a distance. Not used to curbside pickups, I knew this was not just another ride home on a Monday.

It wasn't. As I jumped into the backseat, I learned that our long-rumored move to Chatham, a town twenty miles to the southwest, had come to pass. That afternoon, we drove from St. Mary's straight to our new home. With the move, I inched closer to the sport of lacrosse, if not a game itself. There was no organized lacrosse in Chatham, either, but there was room for it.

Parents watched their sons play baseball with decidedly less zeal than they had in Belleville. Dads, caps tipped down over their noses, dozed off at games, mouths agape. Moms in plaid pants and equally plaid nylon and aluminum beach chairs would open a book and only look up if an errant baseball became of more immediate concern. The game was not king. There were overgrown lawns to mow and hedges to trim, and baseball was fine on a Saturday, if not always convenient. We were not

the next crop of blue-chippers or suited to the nines. Our gray flannel uniforms, I suspected, had their heyday when Lyndon Johnson called the White House home. The town's diamonds were neither manicured nor built with an eye toward appropriate dimensions. They were simply built where they fit. No one complained.

Still, we were a baseball family, and whatever uncertainty life threw at you between April and October, there was always the constancy of the game to set your watch by. My grandfather and great-grandfather both had brief stints in pro baseball, and my dad played while in the Marine Corps during the years of the Korean War.

Chatham eventually embraced lacrosse and now regularly turns out Division I prospects. But not before I'd left for college. In high school, I encountered it here and there. We played prep lacrosse powerhouse Delbarton at baseball throughout my four years. I'd see the lacrosse goals in the distance and noticed them just as a soccer player might notice football uprights. They were there but irrelevant, unless a wayward outfielder drifted toward one. It was only after leaving New Jersey, during my freshman year at Maryland's Mount St. Mary's College (now University), that the sport became something tangible to me.

The school's baseball diamond sat to the southeast of campus at the foot of the long hill that ran down from the mountain's base. Every day of my freshman year I walked slowly up from practice to the infirmary to get a bag of ice for my throbbing right arm. And every day I'd pass Echo Field to my left, where Babe Ruth decades earlier had hit towering fly balls to the delight of a crowd of thrilled students. It was now the domain of the lacrosse team.

The lacrosse players were engrossed in the game that I dismissed as a pointless scrum at the time. I looked over blankly, if at all, and the players ignored me in return. I remember in the spring of 1985 sitting with a group of fellow freshmen on the first floor of the Mount's Pangborn Hall. A lacrosse player sat stooped at the end of his bed, repeatedly pounding a ball into the mesh pocket of the head of his stick.

"What're you doing?" I asked, presuming he was taking out some pent-up frustration.

"Breaking it in," he responded, without looking up.

"I didn't know you had to break them in like baseball gloves," I said.

Not skipping a beat, he said, "I didn't know you had to break in baseball gloves." Clearly baseball wasn't king everywhere, especially Maryland. After that year, I transferred to Virginia's James Madison University, and the momentary blip lacrosse made on my radar vanished.

I eventually moved back to Maryland, and a quarter century later, I know that lacrosse's devotees extend far beyond the turf of Echo Field to every corner of the state. My two oldest sons played baseball, but my youngest gave up the game to try instead the one his state and friends embraced.

In the time since he began lacrosse, I've become a much better fan than the one who could shout only "Go!" for encouragement. I've since coached at the youth level and found that some of the spacing and transition of hockey—a game with which I was much more familiar—thankfully apply to lacrosse as well. I now regularly attend games and watch live ones on television, and I am amassing a nice collection of recorded games. I watch to learn the ebb and flow of the game and its strategies, but also simply because it's a thrilling, skilled sport.

"Getting" lacrosse requires a lot of watching and, ideally, playing. I've tried my hand at both an outdoor game and an indoor "box" lacrosse game to see how it sets up from field level. I hope to do more. I've also written about the sport for a number of outlets, including the *New York Times* and *Wall Street Journal*. Although no longer the outsider I once was, I wanted to make a measured effort to get "inside" my adopted state's all-consuming passion. It's easy now to understand why it's so popular.

With lacrosse's past, once you start digging, questions loom at every turn. Why does it have such a long history in places like Canada, New York and Maryland, while it was ignored for years in others? Why did Maryland develop a style that for a long time (and, in some instances, still today) is considered different than that of other states? Why are so many like me, even in Maryland, taken with a game they may have come to know only through their children?

Fortunately, there is no better place to learn more about the game, its long history and many teams than right here in the Old Line State.

THE GAME ARRIVES AND A UNIVERSITY EMBRACES IT

Lacrosse's earliest roots can be traced to a region that later became parts of Lower Canada (a British colony from 1791 to 1841) and upstate New York. The game was first developed by Native Americans within the Six Nations of the Iroquois and was played long before Europeans settled in the area.

The Native American version could be brutal and required extraordinary endurance. The rules varied among tribes, and teams could have as many as one thousand players to a side. The goals were sometimes more than a mile apart, and a single game could last several days. The stick was as much a weapon as it was a piece of equipment, and as often the former as the latter. Each player could disable members of an opposing team as part of the overall effort to either score or assist his side.

The stick's resemblance to a weapon was no coincidence. The Mohawks called their version of the game *tewaaraton* (alternately spelled as *tewaarathon*), or "little brother of war," which now lends its name to the annual Tewaaraton Award for college lacrosse's best player. Because of the endurance required and the injuries that had to be borne, it was considered excellent battle training.

When French settlers in the region first saw the game played by Native Americans, they found the sticks reminiscent of a bishop's staff or crosier and dubbed it "la crosse." The stick today is still occasionally referred to as a crosse. The earliest lacrosse sticks were made of wood and were sharply curved at the top to form a hook of sorts. The interior of the curve was in some manner "webbed" and allowed for catching, striking and passing the

The National Lacrosse Hall of Fame logo includes a nod to the sport's Native American founding. *National Lacrosse Hall of Fame.*

ball. Given its largely oral history, it is hard to place an exact date on when the sport originated, but estimates typically trace it back to five hundred years ago or more in North America.

The origins of lacrosse among European settlers in Canada can be traced to the shaping of a more standardized form of the game in about 1840. The sport's first official lacrosse organization, the Olympic Club, was founded in Montreal in 1842. Around this era, when the European descendants played Native American teams, they would lose so frequently and thoroughly that they were often allowed extra players.

The Montreal Lacrosse Club was another early seminal lacrosse team, founded in 1856. One of its members, George Beers—ironically a dentist by trade—became one of the strongest advocates of the tooth-threatening sport. In 1860, he produced a brochure of standard rules, field dimensions and number of players allotted per side. He has been called by many "the father of modern lacrosse." Another early club, featuring Native American players,

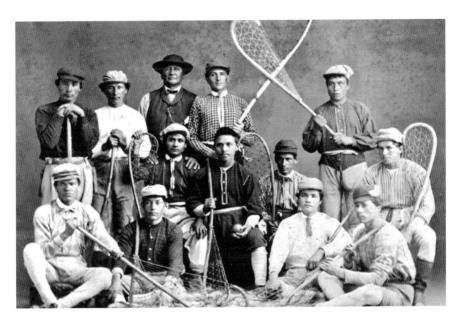

Montreal's Kahnawake Lacrosse Club of the late 1860s was one of the earliest traveling club teams. *Library of Congress.*

was Montreal's Kahnawake Lacrosse Club. In the United States, a team of Native Americans first introduced the sport to Troy, New York, around 1868. Teams formed there and, within several years, in New York City.

Maryland initially encountered lacrosse when members of the Baltimore Athletic Club competed in a track meet in Newport, Rhode Island, in August 1878. While there, they saw their first lacrosse match and returned home infatuated with the game and a newly purchased batch of lacrosse sticks. "Lacrosse came to Baltimore in the summer of 1878, under favorable auspices," the *Baltimore Sun*'s Craig E. Taylor later wrote in a 1947 look back at the sport's history.

By September, the track turned lacrosse athletes began practicing, and on November 23, 1878, they played an intra-club match before a few hundred fans at Baltimore's Newington Park. Newington was known primarily for baseball, although history would ironically prove it the spot that helped launch that sport's chief competitor for athletic talent in Maryland.

The athletes took their speed and finesse to the lacrosse field. While the games could be as rough as those of their northern counterparts,

the Maryland athletes forged a divergent style right from inception. It emphasized a quick first step, not coincidentally the stock-in-trade of a good sprinter in track. With time, regional differences—as with regionalism itself—have diminished, but lacrosse in Maryland still holds remnants of that early influence of track.

At the time, Montreal native John R. Flannery, widely considered the "father" of American lacrosse, was helping establish the sport in the nation's Northeast. Flannery moved from Montreal to Boston after taking a position with the Standard Oil Company. Within several years of his arrival in the United States, he moved again, this time south to Brooklyn. It was there, in 1879, he founded the United States National Amateur Lacrosse Association. It consisted of nine club teams from Massachusetts, New York and Pennsylvania. The nine included club representatives from Harvard and New York University.

Flannery was an active player, coach and vocal proponent of the game. "Lacrosse is one of the most scientific and soul-stirring exhibitions of manly grace, endurance, and strength that the modern athlete is capable of displaying. There is no game in which individual skill shows to better advantage," he said of the sport.

Shortly after its arrival in Baltimore, Johns Hopkins University—which opened its doors two years prior to the Newington Park game—had several students interested in the sport and willing to pay the one-dollar monthly fee required to join the Baltimore Athletic Club's team. Flannery, while starting the first official college team at Hoboken, New Jersey's Stevens Institute of Technology, also lent a hand to Johns Hopkins in beginning its team. By 1883, Hopkins was fielding a short-lived team, followed by one that returned permanently in 1888.

The fledgling university saw in the sport an opportunity to help elevate its overall stature, placing it athletically in the company of such well-regarded schools as Harvard and New York University. The Johns Hopkins lacrosse team, infused with the track and field influence of the Baltimore A.C., did just that. Hopkins also encouraged the development of the sport among local prep schools. The sentiment, novel at the time but now the norm, was that Hopkins would do much better if students arrived on campus with some prior knowledge of lacrosse.

By the late 1890s, lacrosse was so popular at the young university that a special order of the "Flannery Celebrated Lacrosse Sticks" was manufactured for the Johns Hopkins University team. Flannery, fortunately for the sport, did not struggle with trepidation about promotion. The sport also found root among Baltimore-area newspapermen, who embraced lacrosse much sooner

Face-off techniques as shown in Henry Chadwick's 1893 *Reliable Book of Outdoor Games*.

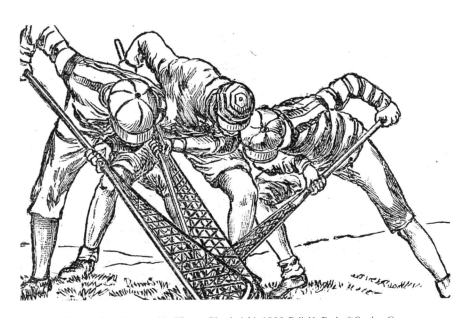

A loose ball scramble illustrated in Henry Chadwick's 1893 *Reliable Book of Outdoor Games*.

than their peers in other cities. "Another big thing that helped Baltimore lacrosse was that the newspapers covered it. I looked at papers from the 1920s, and they covered lacrosse like most papers were covering football and baseball," said Hall of Fame archivist Joe Finn.

A unique group of initial athletes, a university's quick embrace, area athletic clubs and the unique development of local high schools all coalesced together to create an unmatched depth of talent and expertise in the sport of lacrosse in Maryland. And so began the Old Line State's ascent as one of the game's strongholds in the United States.

JOHNS HOPKINS

J ohns Hopkins University was founded in Baltimore in 1876 and bears the name of the merchant, philanthropist and abolitionist who conceived of and provided for its creation. Johns had the unusual, seemingly plural version of the more common "John" as the result of a family last name transformed through the decades into a first. His great-grandmother Margaret Johns was the daughter of a wealthy landowner in Maryland's farm-laden Calvert County. In 1700, Margaret married Gerard Hopkins, and one of their children received the name of Johns Hopkins.

A grandson of that first Johns Hopkins, and the second to bear the unique name, was born in 1795 on the family's tobacco farm. It was this Johns who much later funded and lent his name to the university and hospital.

Johns was the son of a Quaker farmer, and at the age of twelve, he ended his formal education and went to work on the family farm when the Hopkinses made the decision in 1807 to emancipate their slaves. By the age of seventeen, Johns moved to Baltimore to live with his uncle and learn a decidedly more urban trade: the wholesale grocery business. Not long after partnering, the two had a falling out over the elder Hopkins's reluctance to accept whiskey as a form of payment from farmers for their goods. Johns had no such reservation.

The two parted ways, and Hopkins went into business first with a partner and then three of his brothers. Hopkins Brothers prospered, selling goods throughout Virginia, North Carolina and parts of Ohio, as well as their native Maryland. The brothers accepted payments for goods in whiskey,

sometimes then reselling it under the label of Hopkins' Best. Johns rarely traveled, never married and failed to develop a penchant for expensive habits or tastes.

His wealth grew as he took his earnings and invested throughout the region in real estate and a wide range of commercial ventures, including the Baltimore & Ohio Railroad. He had a major impact on the city's developing prosperity and was a wealthy man by the time he retired in 1847.

In 1867, six years prior to his death, Hopkins organized two corporations, one for the creation of a hospital and a second for a university. He divided $7 million equally between them. At the time, it was the largest philanthropic gift in the history of the United States. Johns Hopkins died on Christmas Eve 1873. By 1876, the doors of Johns Hopkins University opened, and the hospital began operation in 1889. A medical school that jointly utilized the university and hospital began in 1893, and in keeping with the social progressiveness of its namesake, it accepted women on equal footing with men.

The university campus was sited several miles to the north of the city's harbor area, where there was open acreage to grow and more than ample room for its first athletic teams. Soon after it opened, the school embraced lacrosse. In turn, the Johns Hopkins lacrosse program proved an incubator for the growth of the sport in the Baltimore region and beyond.

Hopkins first formed a team in the fall of 1882, the same year as the formation of the Intercollegiate Lacrosse Association (ILA), one of the earliest

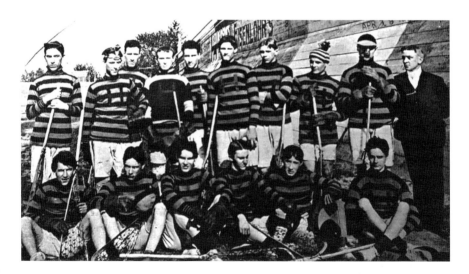

By the late nineteenth century, Johns Hopkins had already become a dominant presence among active collegiate lacrosse teams. *National Lacrosse Hall of Fame.*

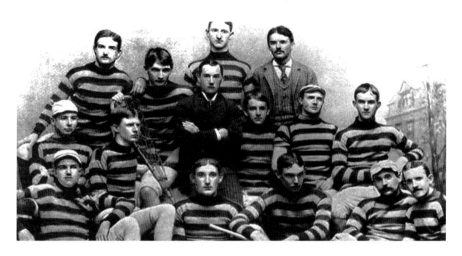

Johns Hopkins's 1899 National Championship team. *National Lacrosse Hall of Fame.*

assemblages of college lacrosse teams in the country. That team disbanded after the 1883 spring season, and the university officially reorganized a team in 1888.

By 1891, the lacrosse team had captured the ILA championship and added another in 1898. It went on to titles in 1899, 1900, 1902 and 1903. The leading defenseman for Hopkins from that era was William C. Schmeisser, who began his coaching career while still a player in 1902. A Baltimore City College (high school) native, an annual award bearing his name is given to the nation's most outstanding defenseman.

One local player deserving special attention among countless players from the turn of the last century is another Baltimore native, Henry S. Frank. Frank was born in 1887 as one of nine children. He attended Baltimore City College and went on to become a lacrosse standout for Hopkins. He was scheduled to graduate in 1908, but in the same year a committee visited Henry's father and pleaded with him to allow the younger Frank to remain at college an extra year to lend his efforts to the lacrosse team. They were effective in their persuasion (it was unlikely that the lacrosse-loving Henry needed the same plea), and in 1909, Frank captained the team, leading the Blue Jays to another national championship.

In the classroom, Henry studied law to conclude his stay at Hopkins, and following graduation in 1909, he took over the family business established just after the Civil War in 1865. He became an integral part of Baltimore's civic life and Jewish community, serving on the board of Sinai Hospital and as the vice-president of the Baltimore Hebrew Congregation for a quarter

This photo of Homewood Field in the early 1920s shows a packed house for a Blue Jays game. *National Lacrosse Hall of Fame.*

century. He died in 1963 and was posthumously elected to the Lacrosse Hall of Fame. He is also a member of the All-Time Johns Hopkins team.

Hopkins's Homewood Field became the home for lacrosse during Frank's era in 1906. It is sometimes referred to as the "Yankee Stadium of Lacrosse," and although the original structures of Homewood have been replaced over time, the site of the field remains the same. Walking through the current brick-and-concrete stadium entrance from the city's University Parkway, the teams' accomplishments become quickly evident by glancing left or right along the concourse. Beneath the stands and adorning the interior walls is a sprawling list of past champions.

The Blue Jays have won a total of forty-four national championships, including nine NCAA Division I titles, twenty-nine United States Intercollegiate Lacrosse League/Association (USILL/USILA) championships and six ILA titles. In the case of the USILL/USILA titles, there was often a tie for the top spot because of the relatively small number of teams and limited schedules. From 1936 through 1970, the Wingate Memorial Trophy was awarded by the USILA (which succeeded the USILL in 1926) to the top college team based on regular-season records. The trophy is named after W. Wilson Wingate, a Baltimore sportswriter credited with dubbing lacrosse "the fastest game on two feet."

The National Collegiate Athletic Association (NCAA) era of lacrosse governance began in the late 1960s. In 1971, it introduced an NCAA postseason playoff tournament. The winner of its annual Division I tournament received the Wingate Memorial Trophy for the first two years of the competition before the award was retired.

Given its lengthy history, a number of rivalries have developed over the years between the Blue Jays—known as variations of "the Blue and Black" until November 1923—and other Maryland opponents. Arguably the biggest rivalry in college lacrosse is between Johns Hopkins and Maryland. It's been contested 112 times through 2015, and the inaugural meeting was in 1895, before Maryland had formally begun its current varsity lacrosse program. Hopkins won the first contest 10–0, and the combined tally of the first five games was 52–0, Blue Jays. In the NCAA era, the two teams have faced each other for the national championship three times, with Maryland winning the first title match in 1973, 10–9, in overtime, at Philadelphia's Franklin Field. Hopkins subsequently claimed the 1974 and 1979 crowns when the two met again for the national championship.

With the ascent of Loyola in recent years, the rivalry between the two schools with Charles Street addresses has gained intensity after being a decidedly one-sided affair in the Blue Jays' favor for decades. What was once dubbed the "Charles Street Massacre" is now more commonly referred to as the "Battle of Charles Street," as the Greyhounds won two of the last three contests prior to the series taking a one-year hiatus in 2015. Hopkins did provide the only blemish on Loyola's otherwise perfect season in 2012 when it topped the Greyhounds, 10–9, with two seconds left in overtime. The Greyhounds returned fire with victories in 2013 and 2014.

Navy is another intense in-state rival. In 2012, the Mids shocked no. 6 Hopkins in Annapolis with an 8–2 victory that is one of the great upsets in regular season play by Navy. This speaks both to the accomplishment and the regard held for the Blue Jays' program. Hopkins led the all-time series with a 60-27-1 mark against Navy through 2015.

The men's lacrosse team has not only represented Johns Hopkins on the field, but it has also represented the country, in the 1928 Summer Olympics in Amsterdam and the 1932 Olympics in Los Angeles. Lacrosse was an exhibition sport both times. "But when the timekeeper sounded the victory signal for Hopkins and the death knell for the hopes of the College Park stick wielders, the championship team of America had been picked and it was Johns Hopkins University, Baltimore, Maryland," W. Wilson Wingate wrote at the time of the 1928 Blue Jays winning the right to represent the United

States in the Summer Olympics in Amsterdam. In the 1928 games, Hopkins went 1-1 as the U.S. team and tied with Canada and Great Britain.

In 1932, the U.S./Hopkins team faced only one other competitor, Canada, and played a series of three games. The U.S. took the series, 2-1. The captain of the 1932 team was Jack Turnbull, who had graduated in just three years from Hopkins but garnered All-American honors each year. His older brother, Doug, earlier attended Hopkins and in 1925 became the first lacrosse player to ever earn first-team All-American honors for four straight years.

In October 1944, Jack Turnbull was killed during a bombing run in World War II. In 1946, the Jack Turnbull Award became an annual honor presented to the nation's best attackman. The Jack Turnbull trophy was cast in pewter and set on a claw-legged wooden base in 1947. It resides in the Lacrosse Museum and National Hall of Fame. It could readily hold company with the Stanley Cup as one of the most striking awards in all of sports.

Hopkins has proved perhaps the nation's most fertile ground for producing lacrosse head coaches, either for their alma mater or schools in Maryland and across the country. One of the most famous Hopkins alum turned coach is Bob Scott. Scott graduated from JHU in 1952 after an All-American senior year as a midfielder. He served in the army following graduation and took the reins of the Blue Jays program in 1955. His teams won national championships in 1957, 1959, 1967, 1968, 1969, 1970 and 1974. Scott was awarded the F. Morris Touchstone Award as the USILA Coach of the Year in 1965, 1968 and again in 1972.

In 1974, under Scott, Hopkins represented the United States at the World Lacrosse Championships in Melbourne, Australia, and captured the title. Following his retirement from coaching that year, Scott became Hopkins's athletic director and provided steady guidance for the university's sports programs until 1995. He added to both lacrosse history and the Blue Jays' place in it when he authored the definitive work on college lacrosse, *Lacrosse—Technique and Tradition*, in 1976. It is required reading for those interested in the sport and was updated in 2006 by current Hopkins head coach Dave Pietramala and writer and fellow alum Neil Grauer ('69).

Scott was voted into the National Lacrosse Hall of Fame in 1976 and in 2013 received the Spirit of the Tewaaraton Award for his lifetime of contributions to the sport.

Henry Ciccarone, a Maryland native and a three-time All-American midfielder for Scott's early 1960s teams, succeeded him in 1975. Ciccarone

graduated from Severna Park's Severn School (presently a member of the highly competitive MIAA-A) and several years later became a star under Scott at Hopkins (1960–62).

He eclipsed his playing career with his coaching accomplishments. He was an assistant coach of the lacrosse, basketball and football teams for the remainder of the 1960s and head coached the basketball team for six seasons prior to taking the helm of the lacrosse team. Ciccarone became the first coach to lead his team to three consecutive NCAA national championships, in 1978, 1979 and 1980. Pikesville native Mark Greenberg was a four-time All-American and shutdown defenseman from that era. Greenberg was voted the nation's most outstanding defenseman in 1979 and 1980, and in 1998, he became a member of the Hall of Fame.

In his nine years as head coach, Ciccarone's teams made it to the NCAA championship game seven times. He retired in 1983 and was inducted into the National Lacrosse Hall of Fame in 1987.

Don Zimmerman, yet another former Hopkins star, was Ciccarone's successor. He coached the Blue Jays for the 1984–90 campaigns and led Hopkins to three national championships, including a perfect 14-0 season out of the gate in 1984. He added additional titles in 1985 and 1987.

Dave Pietramala was an outstanding defenseman for the Blue Jays under Zimmerman from 1986 through 1989. He was named a first-team All-American in three of his four years and has coached Hopkins since 2001. For most of his career, "Petro" was playing defense in front of four-time All-American goalie Quint Kessenich, now a well-known and well-regarded announcer for ESPN. Kessenich, a Long Island native, remembers first encountering the Johns Hopkins campus.

"My visit was in January, and it was gray and cold and the campus was laid out well, with the quads housing most of the academic buildings," he said. As to the lacrosse program, Kessenich was coming from a state power at Long Island's Lynbrook High School and wasn't overwhelmed by Homewood Field or the accompanying facilities of that era. "In fact, on the tour, Coach 'Zim' didn't have the key to the weight room, which I don't think was accidental," he said. As to the composition of the Hopkins teams of his era, "Our team was a nice mix of Long Islanders, Maryland natives and a handful from New England and Denver."

Kessenich and Pietramala combined to help Hopkins to a national championship in 1987. In the 1987 final, Kessenich stopped twenty-one shots to preserve an 11–10 victory for the Blue Jays over Cornell. The 1989 championship was held at Byrd Stadium in College Park, and Kessenich

posted seventeen saves, but this time the Blue Jays were on the wrong side of a one-goal decision and fell, 13–12, to Syracuse.

The Blue Jays next won the NCAA title in 2005 and then again in 2008. The talent-loaded 2005 squad included two well-known Maryland products: Friends School of Baltimore's Kyle Harrison and Paul Rabil from Hyattsville's DeMatha Catholic High School. Harrison was a three-sport standout and lacrosse All-American at Friends; at Hopkins, he went on to win the Tewaaraton Award in 2005. He was voted the nation's top midfielder in both 2004 and 2005 and was a three-time All-American. His father, Dr. Miles Harrison, was a founding member of the storied Morgan State Bears' NCAA team in the 1970s.

The younger Harrison was the number-one overall draft pick of the 2005 MLL draft, and later he represented the country as part of the 2006 and 2014 U.S. National Teams (he suffered a torn hamstring in 2010) and has been named to multiple MLL all-star teams. Harrison went on to captain the MLL's Ohio Machine in 2014 and was named the squad's MVP.

At Hopkins, Rabil earned first team All-American honors his final three years after making third-team All-American as a freshman. He won the McLaughlin Award as the nation's top midfielder as a junior in 2007. Rabil became a perennial all-star in Major League Lacrosse and represented the United States in the 2010 and 2014 World Championships, earning tournament MVP honors in 2010 in helping the team to a gold medal. In 2011, Rabil enjoyed an MLL championship with the Boston Cannons and was part of a 2015 championship New York Lizards team that included Loyola grad and defensive standout Joe Fletcher and leading scorer Rob Pannell from Cornell.

When the Blue Jays were bypassed for a spot in the 2013 NCAA tournament, it was the first time since the tourney began in 1971 that they failed to make a postseason appearance. In mid-May 2013, Hopkins president Ronald Daniels announced that the university would look into a Division I conference affiliation for its mens' and womens' lacrosse teams. (Hopkins's athletic teams outside lacrosse compete at the Division III level and are conference-aligned.) A dimension of the decision was that Hopkins often played a more difficult schedule than some teams that received automatic bids to the NCAA tournament for winning their conference tournaments.

By June 2013, the Blue Jays had their conference. Hopkins began play as an affiliate member of the newly created BIG-10 lacrosse conference in 2014–15. The initial conference lineup included Johns Hopkins, Michigan, Ohio State and Penn State, as well as relative newcomers to the BIG-10,

Maryland and Rutgers. Beginning with the 2016–17 season, the conference's season-ending tournament will result in an automatic NCAA tournament bid for the winners.

In 2015, the team included two outstanding Baltimore products, senior attackman Wells Stanwick and his younger brother, Shack. Shack entered Johns Hopkins in the fall of 2014 after helping Boys' Latin to the high school national championship earlier that year.

Prior to the first game that the Stanwick brothers shared as part of the Hopkins lineup in February 2015, the Blue Jays and the opposing UMBC Retrievers lined up and faced the American flag at Homewood's southeast end. A ceremony that began ninety-five years ago and continues today is the announcement of the three World War I Hopkins lacrosse players and soldiers who gave their lives in service. Since that first ceremony, the number has grown to eight in the ensuing wars. The 2015 season opener had another memorial, dedicated to promising freshman defenseman Jeremy Huber of Las Vegas, who just the week before tragically passed away. The team gathered around his no. 19 emblazoned on the Hopkins turf and drew on his memory and inspiration in earning a win over Don Zimmerman's Retrievers.

The victory earned Pietramala his place atop the all-time wins list among Hopkins head coaches. The Blue Jays' Ryan Brown, a junior and graduate of Towson's Calvert Hall College High School, poured in seven goals to stake an early claim to the All-American honors he would garner later in the spring.

The 2015 campaign stands out for the Blue Jays for capturing the first BIG-10 men's lacrosse championship in the conference's history. After splitting its first dozen games, Hopkins went into high gear in the league's inaugural tournament, beating a 12-1 Terrapins team and then the Ohio State Buckeyes, 13–6, to capture the crown. The winner of the BIG-10 championship did not receive an automatic qualifier in 2015, but the win did help the Jays to obtain an at-large NCAA tournament bid.

Hopkins stormed past Virginia, 19–7, at Charlottesville in the first round of the NCAA tourney. It then knocked off its northern nemesis, Syracuse, by a 16–15 score in a memorable quarterfinal game on the turf of Navy–Marine Corps Memorial Stadium. Next up were the familiar Terrapins. Maryland eliminated the Jays, 12–11, in the semifinals to advance to the championship game. The one-goal margin was typical of the contests between the two Maryland teams. It was the ninth time in the last twenty meetings that a single score was the difference, underscoring both the intensity and parity of the rivalry.

Lacrosse's long history at Johns Hopkins is readily apparent on its Homewood campus. *Janet Kuerr.*

Blue Jays 2014 co-captain and high school and college All-American Rob Guida described well the experience of playing for the sport's most storied program: "It was a pretty special moment stepping onto Homewood Field for the first time. Banners line the top of the stands honoring past championship teams. You realize you aren't just playing for yourself and your teammates, but upholding the tradition of success and excellence of so many past teams."

Few schools have achieved the level of success at any sport, nor have the depth of tradition, that Johns Hopkins has in lacrosse.

NAVY

It was in 1825 that President John Quincy Adams asked Congress to establish a naval academy for the formal training of officers for the U.S. Navy. There were naval schools that existed in the country at the time but not a single school for preparing midshipmen formally through a uniform curriculum. In 1838, the Philadelphia Naval Academy was established for midshipmen preparing for examinations to become officers in the upcoming year, but there still existed no national school.

The sentiment for a single national academy received a grisly tailwind when in September 1842 the American brig *Somers* departed Brooklyn Navy Yard. It was a training ship for teenage volunteers interested in pursuing a naval career. Discipline broke down onboard, and an attempted mutiny ensued. The three mutineers were later hanged, and the efforts of a handful of naval schools teaching midshipmen seamanship through a variety of methods was drawn into heavy question.

Finally, Adams's distant request was heeded when Secretary of the Navy George Bancroft established the Naval School in Annapolis in 1845. He chose the location away from what he felt would be the distractions and temptations of city life. The school lacked Congressional funding, but through Bancroft's efforts, it was established at a former ten-acre army post known as Fort Severn. The school opened on October 10, 1845, with fifty midshipmen and seven professors, four of whom were from the Philadelphia Naval Academy.

Originally, midshipmen attended for five years, with the first and last spent at the school and the intervening three aboard ship in active service

following a strict regimen. In 1850–51, the school was reorganized as the United States Naval Academy (USNA), and a course of study of four consecutive years was set. Summers were given over to a practice cruise and replaced the active service of the middle three years.

During the Civil War, the USNA was moved to Newport, Rhode Island, but returned to Annapolis in 1865. In the postwar years, the curriculum and organization of the academy were greatly improved as they drew on recent wartime experiences in setting standards.

Navy's lacrosse program began in 1908, when two former Johns Hopkins players, Bill Hudgins and Frank Breyer, volunteered to organize and coach its first lacrosse team. The Navy men played their initial scheduled game against the alma mater of their two coaches on April 4 of that year. Hopkins beat Navy, 6–1, and the Mids finished up the year at 1-2. By 1910, Navy had learned enough from the two Hopkins grads to turn the tables and earn a 7–6 victory against JHU.

Since its inaugural season, Navy has compiled seventeen overall national championships, including a streak of eight consecutive titles from 1959 through 1966. All seventeen have come under the guidance of a steady line of long-tenured head coaches.

George Finlayson took over as head coach in 1911 and remained until 1935. Finlayson led the Mids to their first undefeated season in 1912 and a second in 1914. The entry of the United States into World War I caused the cancellation of the 1917 season after just two games, both victories. It also marked a small portion of an undefeated streak that would extend over seven campaigns. From the mid-1916 season until the final game of 1923, the Midshipmen won forty-five consecutive games.

William H. "Dinty" Moore followed Finlayson in 1936. Moore was born in Baltimore on July 11, 1900. He attended Baltimore Polytechnic Institute, known locally as "Poly," and graduated in 1919. From there he went on to attend Johns Hopkins, graduating in 1923. While at Hopkins, Moore played lacrosse until an injury sidelined him in 1922 and ended his undergraduate playing days. Following college, he played for Ruxton's L'Hirondelle Lacrosse Club from 1924 to 1928 and continued to play locally through 1930.

Moore coached for a total of thirty-two years. He founded the program at St. John's College in Annapolis and coached there from 1927 through 1935. In his first efforts to start the team, Moore couldn't find enough players so emptied much of the baseball bench to fill his roster. While under Dinty, St. John's represented the United States in 1931 in several international competitions that included a series win over an aggregated Canadian squad.

His next stop was less than a mile away at the Naval Academy, where he stayed through 1958.

Moore was at the helm for eight undefeated teams—1929, 1931 and 1935 with St. John's and 1938, 1945, 1946, 1949 and 1954 while leading the Midshipmen. He also won two additional national championships when not undefeated, one in 1930 leading the "Johnnies" and another with the Mids in 1940. At the time, it was the greatest number of championships ever won by a coach. Of note in the 1945 campaign was the Mids tying Army in their season opener. At season's end, the two finished tied again, this time as co-national champions.

Moore also coached Navy's all-time leading goal-scorer, J.H. Lee Chambers, who found the back of the net 143 times for the Midshipmen. Chambers was named a first-team All-American three times (and second team one year) and is a member of the Hall of Fame.

Away from the lacrosse field, Moore joined the *Baltimore American* newspaper after graduating college and later became the provost of his alma mater from 1924 to 1926. Away from the lacrosse field, his career was in academia, and he went on to become the assistant president of St. John's College and then co-headmaster of Baltimore's Marston School. He also served as the president of Lutherville's Maryland College for Women until its closure in 1952.

Navy's second lacrosse coach was also a prolific writer. He founded the *Lacrosse Newsletter* and published it for three years. Moore's articles appeared in a wide range of publications, including the *Navy Manual* and the *Christian Science Monitor*. He also authored two pamphlets, *Lacrosse Techniques* and *How to Play Lacrosse*. He contributed many articles to the *Lacrosse Guide*, published annually by the NCAA. In aggregate, his teams won 232 games and lost just 57.

Although Moore was irreplaceable, Navy managed to do so with Willis "Bildy" Bilderback in 1959. He was a native of the bustling New Jersey resort town of Asbury Park and graduated from Rutgers University in 1930. As a Scarlet Knight, he earned varsity letters in football, lacrosse and wrestling. Once Bilderback graduated college, he immediately began coaching high school football and continued until entering the U.S. Navy during World War II as a chief specialist. In February 1944, he was assigned to the U.S. Naval Academy. While there, he compiled a coaching record beyond compare in U.S. lacrosse history.

Bilderback first coached the plebe team in Annapolis from 1947 to 1958 to an overall record of 57-16-3. Included in that span were six undefeated

William H. "Dinty" Moore founded a formidable team in the St. John's College "Johnnies" and later directed Navy. *National Lacrosse Hall of Fame.*

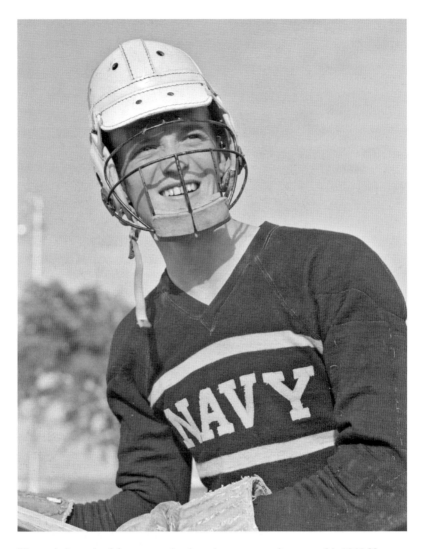

The early inroads of face protection into the game are shown on this 1942 Navy Midshipman. *Library of Congress.*

seasons. He went on to even greater accomplishments as the varsity head coach. He led the Midshipmen to nine outright or shared national championships in just fourteen years at Navy. Included in those nine are the eight titles of 1959–66. During that run, Bildy's 1965 club was the first college team in forty-two years to win the USILA Championship and the National Open Championship, which mixed club and collegiate teams together in competition.

MEN'S LACROSSE IN MARYLAND

Jimmy Lewis, *far right*, and his fellow Midshipmen missed few ground balls in the early 1960s. *United States Naval Academy.*

A cornerstone of those teams was Hall of Fame attackman Jimmy Lewis (a three-time Turnbull Award winner) and a stifling defense. Navy's Mike Coughlin took home the Schmeisser Award in 1963 as the nation's top defenseman, followed by fellow Midshipmen Jim Campbell in 1964 and Pat Donnelly in 1965. Future Hall of Famer Carl Tamulevich brought the award back to Annapolis in 1968.

Following the 1972 season, Bilderback retired for health reasons. All told, he coached the Mids' varsity from 1959 to 1972 and compiled a 123-22-1 mark. In 1973, just a year after his retirement, he was inducted into the National Lacrosse Hall of Fame. He passed away on June 12, 1990, at the age of eighty-one. In his honor, along with that of predecessor Dinty Moore, there is now the Bilderback-Moore Navy Lacrosse Hall of Fame. Opened in 2007, it is an addition to the grandstand on the southwest side of Navy–Marines Corps Stadium in Annapolis.

Dick Szlasa arrived following Bilderback. A former University of Maryland standout in the late 1950s, he was the head coach at Washington and Lee

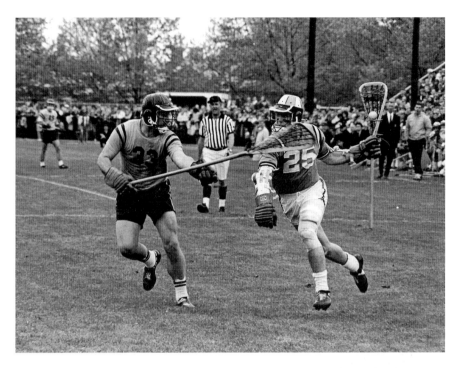

Navy All-American Carl Tamulevich and Hopkins All-American Joe Cowan in a late 1960s battle. *Johns Hopkins University.*

University prior to his arrival. Although once again a new Navy coach with formidable shoes to fill, Szlasa proved up to the job and maintained the Mids' long history of winning lacrosse. Under Szlasa, Navy qualified for ten straight NCAA tournaments, a feat no other Mids lacrosse coach can boast.

He packed many wins and memories into his decade at the helm. In 1975, Navy won six of its nine regular season games and advanced to the national championship against the Terrapins before falling. En route to the title game, the team knocked off first Penn and then the top-seeded Cornell Big Red, who went on to claim the national title in 1976.

For his leadership, Szlasa received the F. Morris Touchstone Award in 1975, given annually by the USILA to its choice as the top Division I head coach of the year. It was under Szlasa that the Mids' all-time leading points-scorer, Jeff Long, blossomed. The attackman from Rochester, New York, posted nineteen goals and a matching nineteen assists his freshman year in 1974. As a sophomore, he received third-team All-American honors, and in 1976, he established an academy record with nine assists in a win over Hofstra. The same year, he earned second-team All-American honors.

"As busy as the day was, and as tired or worn down as I might have been, the thing I looked forward to every day was putting on the equipment, going to practice and playing lacrosse. It's what I lived for," said Long, the head coach at New York's Ithaca College since 1988. "It was all worth it when we put on the uniform and stepped onto the pristine grass of Navy–Marine Corps Memorial Stadium. To this day, I still miss it," he added.

In 1977, Long's senior year, the Midshipmen made it to the national semifinals before bowing to undefeated and repeat champions Cornell. That year, he earned first-team All-American honors. He left the team with the record for the most assists in a game (9), in a season (53) and career (140). He also departed Annapolis with 233 points, still the all-time record for the Mids. "Jeff was one of the most competitive athletes whom I have ever coached," former coach Szlasa said upon Long's induction into the National Lacrosse Hall of Fame in 2007. "He was an extremely unselfish player and was just as happy with an assist as he was with a goal."

Mike Buzzell earned All-American honors under Szlasa's tutelage and set the Navy record with thirteen points in a single game. In 1979, Buzzell claimed the Navy mark for the most points in a season with eighty-five. The prior season, he broke the existing record alongside teammate Brendan Schneck (Schneck transferred to Hopkins following the 1978 campaign), as they both tallied seventy-eight. In 1978, Buzzell set the still-standing record for goals in a season by a Midshipman with fifty-one. Clearly Szlasa's teams could score, which helped him end his time at Navy following the 1982 season with an overall mark of 85-44.

Szlasa's coaching skills were passed along to some of his former players, including Long at Ithaca and attackman Pace Kessenich ('82). Kessenich, the older brother of former Hopkins goalie Quint, arrived in Annapolis as a wrestler and switched over to lacrosse his freshman year. He progressed steadily through the JV ranks and up the depth chart into his senior campaign. He went on to coach Colgate from 1992 to 1995, earning Patriot League Coach of the Year honors in 1993 before later moving on to a career in business. Like Long, he remembers the time on the lacrosse field as a respite from what is the busy life of a Midshipman. "At Navy, our favorite three hours of the day were practice. We had six periods…no matter how tough Szlasa was, it couldn't compare to what was going on in the rest of our day," said Kessenich.

Coming from Long Island's Lynbrook High School, where he was a three-sport athlete, Kessenich also noticed distinctions while at Navy and later at Colgate between Maryland and New York styles of play. After noting that

the Maryland players of his era tended toward a controlled, half-field set style of play, he added that, to generalize, "up on Long Island it was a lot more spending time on fast breaks, scrambles, opening it up a little more."

Bryan Matthews followed Szlasa, leading the Mids from 1983 to 1994. In 1986, Matthews garnered the Touchstone Award for the second time in his career as Navy went 9-3 in the regular season and advanced to the NCAA tournament before falling in the second round. In 1987, five Midshipmen were named to All-American teams, and the team again made the tournament. There, attackman Paul Basile set a record for the most assists in a playoff game with eight.

The 1989 season under Matthews was punctuated by the most lopsided victory over Army in the series' history as Navy prevailed, 21–1. The team advanced to the second round of the NCAA tournament before falling to eventual champion Syracuse. The Mids again appeared in the tournament from 1992 to 1994.

Head Coach Richie Meade's tenure at the USNA began in 1995. Meade is a native of Long Island's Nassau County. He played first at Nassau Community College and then transferred to UNC–Chapel Hill, graduating in 1976. Meade had several stops en route to the Navy top job, including a four-year stint at the University of Baltimore from 1980 to 1983 before the university ended its athletics program. He is a member of the University of Baltimore's Sports Hall of Fame.

While at Annapolis, Meade's teams won five Patriot League regular season and tournament titles. The most memorable effort was the 2004 squad's run to the NCAA title game. The 2004 team made an impression in its first year in the Patriot League by promptly winning the league championship. It was unranked coming into the season but ended the year with a 15-3 mark and a number-two ranking, narrowly missing a national championship by falling to Syracuse, 14–13. The championship game was played before forty-three thousand largely partisan fans at Baltimore's M&T Bank Stadium.

Late in that game, goalie Matt Russell came out due to an unknown injury and was capably replaced by Cody Finnegan. Initially, the Navy bench thought Russell might have dislocated his shoulder, but he had instead suffered a fracture. "He didn't separate his shoulder; it was a broken bone. Since they thought it was a dislocation, they tried to pop his shoulder back in," said Coach Richie Meade. "I was holding him and looked him right in the face while they were doing that, and he looked me right back and started smiling. 'I'm alright, coach.' He was tough."

Russell earned the Kelly Award as the nation's top goaltender despite not becoming the starter until the third game of the season. Three Looney brothers—senior Brendan and younger brothers Steve and Billy—were cornerstones of the team. Steve and Billy each earned All-American honors at Navy. Brendan Looney was a relentless defenseman, picking up the sport after arriving on campus as a football player. Looney posthumously received the Spirit of the Tewaaraton Award on May 29, 2014, for his ability on the field and for his ultimate sacrifice in serving his country as a Navy SEAL.

Meade tutored thirty-nine All-Americans at Annapolis, and his teams made seven NCAA tournaments. His accolades include the 2004 Touchstone Memorial Award and twice earning the Patriot League's Coach of the Year Award, first in 2004 and again in 2007.

The latest coach carrying on the Navy tradition is Rick Sowell. Sowell, a graduate of Chestertown's Washington College, is the first African American head coach at the Naval Academy. Sowell arrived in Annapolis from Stony Brook University in New York, a member of the America East conference (Maryland's UMBC is a fellow America East team). Sowell posted 13-4 and 10-4 marks in his final two seasons there before taking the Navy position for the 2012 season. In his last two seasons at Stony Brook, the Seawolves also captured America East championships, and Sowell was named the conference's coach of the year. Prior to his five-year stint at Stony Brook, Sowell restarted the dormant lacrosse program at St. John's University in Queens, New York, in 2005.

His coaching career extends back to 1990, when he took on an assistant role at Georgetown. He served on the staff there for nine years, and during his tenure, the Hoyas posted an 80-39 mark. He also previously served as head coach of Dartmouth from 1999 to 2003.

The highlight of his first year in Annapolis was Navy's 8–2 victory over no. 6 Johns Hopkins at Navy–Marine Corps Stadium on April 21, 2012. The Mids finished the season at 6-6 without a postseason ahead but left an indelible mark on the 2012 landscape with the win. Senior R.J. Wickham finished with eighteen saves, many of them at point-blank range. It was the lowest-scoring output by Hopkins since 1966 and the fewest goals scored by the Blue Jays against Navy since 1925. The Mids fell to 3-10 in 2013 and 4-10 in 2014.

In early 2015 action, Sowell's work began to pay off as the Mids were 7-2 overall and 5-1 and in first place in the Patriot League. "We are still a very young team, and you can see how we are evolving each and every game. It's exciting to see our team playing at this level as a whole,"

Sowell said after a critical win over Boston University in week nine of the 2015 campaign.

His comments gained even more credence when on April 11, 2015, on a clear day in Annapolis, the Mids played host to the Army Black Knights. Army came in at 8-3 and having won its last three. Army jumped out to a 4–1 lead through one, but the Mids battled back and ultimately went on a 7–0 run en route to a 10–7 victory. Freshman midfielder Casey Reees, a graduate of Baltimore's Boys' Latin School, buried a hat trick. Fellow midfielder Colin Flounlacker of Kent Island scored an acrobatic goal that put Navy ahead for the first time, 7–6, in the fourth quarter. Goalie John Connors stood tall for the Mids in shutting down Army late in the game.

It was the first Navy win over Army after six straight losses to the Cadets; it notched a spot in the Patriot League playoffs and punctuated the return of winning lacrosse to Annapolis. Navy went on to end the season with a 9–8 victory over Air Force, closing out the campaign with a promising 9-5 mark.

UNIVERSITY OF MARYLAND

In 1856, Maryland Agricultural College was chartered, at the location that became the University of Maryland's primary campus in College Park. The earliest years were financially uncertain for the college, as they were for many institutions of higher education in the nineteenth century, particularly around the time of the Civil War. By 1864, the year prior to the war's end, the agricultural college was bankrupt and briefly became a prep school. In 1866, it failed to open at all. The following year, it was only able to do so with the help of state funds, and just eleven students made up the entire student body.

Maryland Agricultural College persevered through the late nineteenth century. There are references to a Maryland club team as early as 1895, and in the 1911 *Spalding's Athletic Library Official Lacrosse Guide*, the university is alluded to as "having lately taken up the game." It again appeared in the 1922–23 guide as the owners of a 5-2 mark from the 1921 season. Lacrosse records from this era are especially erratic, as teams drifted in and out of varsity, "B" team and club status regularly. Colleges often pitted their underclassmen against high school competition and, even more often, their varsity against men's club programs. The focus was on the game, not on the classification of competition.

Maryland fielded a team for the better part of the years between 1895 and 1923, but not consistently at the varsity level until 1924. One year prior to the 1921 team earning its reference in *Spalding's*, the school officially became the University of Maryland. Separate Baltimore (University of Maryland) and

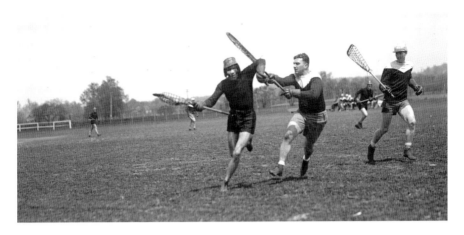

The University of Maryland was successful early and often. Here the Terps' attack faces Lehigh, circa 1925. *Library of Congress.*

College Park (by that time the Maryland College of Agriculture) campuses combined into one university.

In its first year in the United States Intercollegiate Lacrosse League (USILL) in 1924, the team was led by Head Coach R.V. Truitt. The USILL was the precursor to the United States Lacrosse Association (USILA) of 1926, which still exists today. Truitt took the reins at Maryland in 1919 and stayed in the position until 1927, but that barely touches on his story.

Earlier, while an undergraduate at College Park, Truitt competed in both track and lacrosse in each of his four seasons (1911–14). In his senior season, he was captain and student coach of the lacrosse squad. The Snow Hill, Maryland native's talents extended well beyond lacrosse. In World War I, he served as an advance pilot in the United States Army Air Service, the forerunner to today's United States Air Force. Flying aircraft in any war is clearly dangerous; the World War I pilots may stand alone for their courage, battling lethal enemies and, as often, thwarting the life-threatening mechanical failures of their aircraft. Truitt survived both.

After earning his Bachelor of Science from Maryland, he went on to earn his PhD at Washington, D.C.'s American University. He taught zoology from 1925 to 1941 at Maryland and while there extensively studied the survival of the oyster population in the Chesapeake Bay in an era that largely predated environmental awareness. In 1926, he founded the Chesapeake Biologic Laboratory on Solomons Island, now one of a handful of campuses composing the University of Maryland Center for Environmental Science.

When not coaching or researching, Truitt officiated games. He officiated an international series between St. John's College and a team of Canadians in 1931 (referenced in the Navy chapter), as well as a series of battles between two of the most prominent club teams of the era, Baltimore's Mount Washington Lacrosse Club and the Crescent Club of Brooklyn. As with St. John's/Navy head coach William H. "Dinty" Moore, Truitt also contributed articles to Baltimore newspapers on lacrosse, including Sunday features on the sport.

To broaden interest in the game, Truitt handled the logistics of bringing two teams from Oxford-Cambridge across the pond to face a series of American college teams in 1925. He was in charge of schedules and travel itineraries, including receptions at the White House and the British embassy. When World War II broke out, Truitt again answered the call and earned a U.S. Navy commendation for his research on underwater sound.

Returning to his efforts on the lacrosse sidelines, Truitt's "Old Liners," as Maryland teams were known at the time, quickly made an impression in 1924 when they snapped Navy's forty-six-game winning streak in their very first USILL game. The game was held on April 12 in Washington, D.C., and was the first major intercollegiate game in the city. It drew an estimated five thousand fans to see Maryland capture a 5–3 victory. "Maryland Defeats Navy at Lacrosse. Sailors' Long Streak Broken," read the April 13, 1924 *Baltimore Sun* headline the day following the victory.

Later in the same season, they beat a previously undefeated Johns Hopkins squad, 4–2. They ended the year as the USILL's Southern Division champions with a 5-2 record. The next season, they successfully defended the title, clinching it with a 3–1 defeat of Johns Hopkins.

Whereas the USILL had limited the number of teams, the USILA did not. With the change to the USILA in 1926, four Maryland teams—Maryland, Johns Hopkins, Navy and St. John's—soon competed frequently and pushed one another to new competitive heights. Truitt completed his tenure after the 1927 season. His teams compiled a 22-8-1 mark under his guidance and became a fixture at the varsity level.

In 1928, Maryland remained strong and finished with a 9-1 overall record under new head coach Jack Faber. The mark tied the team with three others in the country that suffered only one loss: Hopkins, Navy and Rutgers. They were collectively awarded gold medals as the best college teams in the nation. The same year, arrangements were made to include lacrosse as an exhibition sport at the Summer Olympic Games in Amsterdam. It gained status as an Olympic sport in 1904 but was later dropped from the lineup of

summer games sports. The exhibition status was a hoped-for step to a full return as an Olympic sport. The American Olympic Committee at the time was under the direction of General Douglas MacArthur, who delegated to a subcommittee the method for determining the country's representative squad in lacrosse.

In response, a tournament of both collegiate and amateur club teams was organized. The field included Johns Hopkins, Army, Navy, Rutgers and the Mount Washington Lacrosse Club. Although Maryland advanced to the finals, it fell to Johns Hopkins, 6–3, before twelve thousand onlookers at Baltimore's six-year-old Municipal Stadium. The next season, a powerhouse St. John's team handed the Old Liners their first home-field loss in more than a decade.

At the 1932 Los Angeles Olympic Games, lacrosse again made an appearance as an exhibition sport. The qualifying field was a single-elimination tournament to decide the country's representative. The field included the Crescent Athletic Club of Brooklyn and an all-star team of Native American players. From the collegiate ranks, Maryland, Johns Hopkins, Navy, Syracuse, St. John's College and Rutgers competed. Maryland started off well, beating Mount Washington in front of six thousand fans, again at Municipal Stadium. Later that day, Johns Hopkins beat St. John's.

The skies opened up for the semifinals, rendering both the field and much of the stadium a muddy abyss. Baltimore's Municipal Stadium—built hastily in 1922—was largely composed of dirt and wood, and a torrential downpour formed small gullies of running water down its sides. Maryland better withstood the elements and edged the Crescents, while Hopkins bested Rutgers. Unfortunately for Maryland, it fell just short again to Hopkins, this time before a rain- (and mud-) diminished crowd of five thousand.

In 1935, the Terrapins (Maryland teams assumed their "new" official nickname gradually in the 1930s) finished tied with St. John's and Navy with one loss in their quest for the nation's top spot. All three proved runners-up to an undefeated Princeton team. In 1936, Maryland was the nation's sole undefeated lacrosse team and, under Faber, garnered the inaugural Wingate Memorial Trophy as USILA champions. The Terps rolled on from there, going undefeated again in 1937 and sharing the national crown with Princeton.

In the cage for both those teams was first-team All-American Jack Kelly. In the three years that he started for the Terps, his squad dropped only one game. Kelly later started the Loyola program, and beginning in 1951, he took on the role of editing the *Lacrosse Coaches Association Newsletter*. Jack changed its name to the more succinct *Lacrosse Newsletter* in 1954 and continued to

edit and publish it through 1974. In conjunction with the annual *Lacrosse Guide* published by the NCAA, it was the sport's best source of up-to-date information.

In 1939, Maryland claimed the USILA title outright. The year 1940 saw yet another perfect season and a national championship, this time via a 10-0 mark. The 1940 squad included Milton Mulitz, a Washington-area native who declined an offer to play basketball at UNC to stay closer to home and represent the Terps in basketball. At College Park, he excelled on the hardwood, garnering All-Southern Conference team honors. He learned to play lacrosse his freshman year at Maryland and went on to become a three-time All-American. He later started the Bullis School in Potomac, which boasts a strong lacrosse program befitting its founder. For his athletic accomplishments, Mulitz was elected to the University of Maryland Hall of Fame, as well as the Greater Washington, D.C. Jewish Sports Hall of Fame.

In the early years of World War II (1941–43), the Terps went 21-5 before suspending play in 1944–45 due to the conflict. After nearly a decade of solid and then increasingly strong teams, Maryland went undefeated in 1955 and 1956 and claimed consecutive national championships. By this time, it was led by co-head coaches Faber and Al Heagy. The duo served as joint head coaches for thirty-one years and had a record of 224-52-2. Faber coached

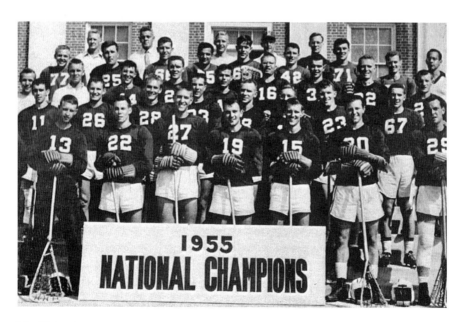

The University of Maryland's 1955 national championship team. *University of Maryland.*

for three years prior to Heagy's arrival and Heagy for two years after Faber's departure in 1963.

Maryland shared the USILA championship with Johns Hopkins and Army in 1959 with a 9-1 mark. Over the course of five seasons (1955–59), the Terps lost a total of three games, all to Johns Hopkins. Embedded in that era was a thirty-one-game winning streak, and outside the three Hopkins games, they were 48-0.

In 1967, Maryland dropped a single game to the Navy Midshipmen, but Johns Hopkins defeated Navy the same year to create a three-way tie for the championship by the trio of Maryland colleges. The National Collegiate Athletic Association began hosting a men's lacrosse tournament in 1971 to determine the national champions. Prior to the NCAA era, Maryland compiled eight Wingate Memorial Trophies and one USILA championship.

The team went on to win national championships in 1973 and 1975 in the NCAA era. One of the Maryland greats of that era, or any other, is Long Island native Frank Urso. Urso is one of only four players in the history of college lacrosse to win first-team All-American honors in each of his four seasons. He accomplished the task in 1973, 1974, 1975 and 1976. With Urso on board, the Terps captured ACC titles in 1973, 1974 and 1976. Urso holds the still-standing record for goals by a Maryland middie with 127. Perhaps his most famous tally under Hall of Fame head coach Bud Beardmore was the double-overtime game-winner to clinch a one-goal victory over Johns Hopkins in 1973 and capture the national championship.

Urso won the McLaughlin Award three times as the nation's top midfielder. His accolades on the field border on too numerous to list, but he certainly is at the fore in any conversation about the top midfielder in the history of the sport.

Beardmore led the Terps for a total of eleven years from 1970 through 1980. His ledger there overall was 107-31 and included two national championships, the 1973 victory and another in 1975 against the Midshipmen. He spent his undergraduate years as a Terp and was a three-time All-American. Prior to that, he went first to Annapolis High School and then the Severn School, where he later coached.

Since that era, the Terps have not returned to the top spot in the NCAA Division I, but year after year they post stellar team and individual accomplishments. Hall of Fame coach Dick Edell led Maryland for eighteen years (1984–2001), compiling 171 wins and a .692 winning percentage in the process.

Former Loyola head coach Dave Cottle led the Terps for nine seasons (2002–10) after Edell, gaining the NCAA finals twice and posting an overall

Terps midfielder Landon Carr brings the ball upfield against Loyola in the 2012 title game. *Mike Broglio/Shutterstock.com.*

99-45 mark. A noteworthy game during the Cottle tenure was a March 29, 2009 contest against ACC rival Virginia. Before all was said and done, the two played the longest game in NCAA history, with Virginia ultimately prevailing, 10–9.

Former Navy assistant John Tillman followed Cottle and was immediately successful, making the 2011 and 2012 NCAA title game in his first two years. A memorable Terrapin moment of recent years came in 2011, when Maryland defeated the top-seeded Blue Devils in the ACC tournament after not claiming the league tournament for six years. Grant Catalino earned ACC tournament MVP honors. Maryland repeated the trick in the NCAA tournament when it bested the Blue Devils again, 9–4, this time in the semifinals. Webster, New York native and three-time All-American Catalino rang up a hat trick in the game, and fellow three-time All-American Niko Amato posted thirteen saves.

In 2014, Niko Amato took home the Ensign C. Markland Kelly Jr. Award as the nation's top goalkeeper.

With more than fifty years in the ACC, the Terrapins developed intense rivalries with a number of conference foes, including North Carolina. *Maureen Lingle.*

The 2015 season was the Terps' first season in the BIG-10 for the lacrosse program. The league began lacrosse play with members Penn State, Rutgers, Ohio State, Michigan and an opponent well known to the Terps: archrival Johns Hopkins. Maryland had prior experience as charter members of a new league, as it was one of the original seven Atlantic Coast Conference teams when it began play in 1954.

In 2015, the Terps posted a stellar 15-4 mark. Highlights on the year included a NCAA tournament semifinal victory over Hopkins, a trip to the championship game and a remarkable year for junior goalie winner Kyle Bernlohr.

The red-shirt junior from Akron, Ohio, stepped out of the shadow of the All-American Amato and followed up his Kelly Award with one of his own. Bernlohr set a school record with fifteen wins and boasted the nation's lowest goals against average (6.57/game). The Amato/Bernlohr accomplishment represents the first time a school has won the award in consecutive seasons with different goalies since 1961–62 (Johns Hopkins).

"It was an honor to be recognized with the Kelly Award as goalie of the year. It would not have been possible without playing behind the number

one ranked defense from the very first game to the last. Those guys did their job, and I was very fortunate to reap the benefits of their play all year," said Bernlohr about earning the award.

Over its history, Maryland lacrosse holds a distinction unparalleled by any major lacrosse program. The Terps have never posted a losing season and only four times have finished at the .500 mark. Combined with 459 All-Americans in their history, the Terps sit squarely in lacrosse's very top tier.

LOYOLA UNIVERSITY MARYLAND

L oyola was founded in 1852 and fielded its first lacrosse team in 1938, just months before Baltimore briefly became the epicenter of the sports universe for the Seabiscuit versus War Admiral showdown at Pimlico Race Course.

The school was known at the time as Loyola College, a name it retained until it became Loyola University Maryland in 2009. Some sixteen years before the team began, Loyola gradually transitioned from its urban location on Calvert Street in downtown Baltimore to its Evergreen campus on Charles Street four miles to the north. The new campus was a parcel of largely open space carved out of the larger grounds of the Evergreen House, the former estate of railroad magnate John W. Garrett.

The Gilded Age estate still stands and, in one of many links between the two universities, is currently part of the Johns Hopkins University Sheridan Libraries & University Museums system.

It was in the waning years of the Depression that the lacrosse team began play on Loyola's still relatively new and decidedly more spacious campus. Like the rest of the country, the Depression still weighed heavily on Maryland, and the spring of 1938 was not an inviting one for new undertakings. Maintaining existing teams had proved difficult enough; the school's football team, founded in 1922, withered in the Depression's fiscal depths and stopped play in 1933.

There were informal but organized lacrosse games at Loyola dating back to 1930. They were typically freshman squads that played the majority of

their games against local prep schools. It wasn't until a group of determined sophomores, carryovers from the 1937 freshman team, came together under the direction of former Maryland goalie Jack Kelly that a varsity team was formed. As the school's student newspaper, *The Greyhound*, described him, "Jack has had a world of experience on the lacrosse field, helping the University of Maryland to capture two national inter-collegiate championships…It is generally felt that if anyone can bring lacrosse to Loyola on a successful basis, it is our new coach, Jack Kelly."

Competitively, Loyola played its first year somewhere between the JV and varsity levels. The team met with early success, winning its very first game, 9–4, over a varsity Virginia Cavaliers squad. The Cavaliers entered the game with a 4-1 mark and victories over North Carolina and Duke already to their credit. The *Baltimore Sun* gushed over the win and the general state of lacrosse in Maryland in the days following the victory: "Step up Loyola, and take a bow. The Evergreen athletes belie their nickname. If they were ever green, the University of Virginia wants to know more about it…with Loyola jumping into the lacrosse field with such gusto the lacrosse program in the state will be greatly strengthened. The sport thrives in Maryland. The colleges and leading clubs place crack teams on the field and Maryland usually provides the national champion."

Less than a week after beating Virginia, the Greyhounds—who donned their name when the school implemented football in the 1920s—were poised to play a varsity Harvard squad but instead were surprised to find themselves facing the Crimson's "B" team. Harvard's varsity opted to head to Annapolis to scrimmage Navy. The Greyhounds defeated the Crimson B's, 7–2. That year's slate of six games included contests against Navy (B) and Maryland (B) and two against Johns Hopkins (B). Loyola went 4-2 on the season.

The next year, the Greyhounds upgraded their schedule to include the Blue Jays' varsity team, and the competitive gap between the two programs was laid painfully bare as the Greyhounds fell, 20–1. Those early years were tenuous affairs, with often just a handful of games composing an entire season. As the country pulled out of the Depression only to find itself embroiled in World War II, the college and the nation were understandably focused elsewhere. The team was down to just five games by 1943. In 1944 and 1945, lacrosse was shuttered completely due to the war. In 1946, Loyola played only four games as the school and team transitioned back to some semblance of normality.

Bishop Baker led Loyola through most of the postwar years and had the longest tenure of the coaches of that era, steering the Greyhounds to a 22-

29 overall mark through 1952. After a 2-5 mark in the final year of the Korean War, the Charlie Wenzel era began in 1954 and lasted for seventeen seasons. Wenzel's all-time mark was 62-105, and the team posted just three winning seasons during his tenure. It also received some especially lopsided drubbings at the hands of Johns Hopkins that continued a losing streak to the Blue Jays that would hit thirty games before the rivalry was mothballed in 1969.

Importantly, though, the era established the permanency and stability of the team and also increased the number of games played to a program high of thirteen in 1966. The early 1970s were arguably the program's lowest ebb. After just five wins in 1971, the Greyhounds went a dismal 6-32 overall in 1972–74. By decade's end, however, Loyola reversed course under Coach Jay Connor. In 1981, it reached the Division II NCAA championship game, falling in the final to Long Island's Adelphi, 17–14. The next season, the final under Connor, the Greyhounds moved up to Division I. Connor directed Loyola's all-time leading scorer, Gary Hanley, during his coaching tenure. Hanley (1978–81) is the program's all-time leader in goals (151), assists (160) and points (311).

Dave Cottle stepped in as coach for the 1983 season. Cottle was previously a standout player at Salisbury State College (now Salisbury University), setting numerous school scoring marks. He served as an assistant coach there and then had a brief, highly successful coaching career at the Severn School near Annapolis before taking over at Loyola.

After an initial 5-9 campaign, his Greyhounds rattled off eighteen straight winning seasons, including fourteen straight NCAA appearances and a 1990 Division I national championship game appearance. They lost to Syracuse in that final, but the Orangemen were later disqualified due to a rules violation; the championship title for the year was left vacant. The goalie for the Loyola team in 1990 was senior Charley Toomey.

Dave Cottle continued to lead Loyola through the 1990s, and on his watch the annual game against Hopkins resumed in 1993. The Greyhounds finally defeated the Blue Jays in 1994 by a 17–15 margin to end a fifty-five-year drought. They chalked up an undefeated 12-0 regular season in 1999 before falling to Syracuse in the first round of the postseason.

Mark Frye was a senior midfielder and a three-time All-American for the Greyhounds who played on the 1999 team. The Severna Park native scored ninety-three goals and added forty-one assists in his career (1996–99). Frye went on to an outstanding career with the Bayhawks and also played briefly in the Canadian Football League with the British Columbia Lions.

In 2001, Cottle departed Loyola for the University of Maryland's top spot, and Bill Dirrigl led the team from 2002 to 2005. Following Dirrigl, former Loyola goalie Charley Toomey moved up from assistant coach to head coach beginning with the 2006 season. Toomey is an Annapolis native who attended the Severn School and, like Cottle, later coached there. He started off with a largely even mark at Loyola through his first three seasons, bringing the team in just above .500. In 2009, the program stepped up a gear, still marred by close losses to Johns Hopkins, but improving to an average of three games over .500 per year from 2009 to 2011.

Then came 2012. After going 8-5 in 2011, the Greyhounds entered the 2012 season unranked and largely overlooked. Eric Lusby, Loyola's top attackman, was recovering from a torn ACL that cost him nearly the entire 2011 season. The goalie situation was up in the air. They also still had the unwelcome label of Baltimore's second-best lacrosse team. Yet the Greyhounds surprised the lacrosse world when they won their first dozen games and finished 15-1 in the regular season. Unfortunately, the one loss was to their Charles Street neighbors to the south, the Blue Jays. Still, they persisted to the 2012 finals, and Toomey had his Greyhounds in line for its second national title shot. Sophomore Jack Runkel, under Toomey's tutelage, emerged as the starter and had a goals against average below eight on the year.

The Terps team the Greyhounds face was unseeded in the NCAA tournament but had history on its side as the more accomplished of the two programs. It was Cottle's successor at Maryland, John Tillman, leading the Terrapins in his second season as head coach.

On Memorial Day, May 28, 2012, the seeds planted by a group of determined sophomores in 1938 finally came to their full fruition. The Loyola lacrosse team did what none had ever done at the university in any sport: win a national championship at the Division I level. The setting was Foxborough, Massachusetts's Gillette Stadium, and 30,816 fans showed up to watch two teams based some four hundred miles to the south. It was an all-Maryland final, the first since 1979, when Johns Hopkins faced and defeated the University of Maryland. Despite their proximity—the two schools are roughly forty miles apart—Loyola and Maryland had not faced each other in fourteen years.

The temperatures were in the low seventies at Gillette and warmer on the turf field. Back in Maryland, they were blistering. The dorms of Loyola were largely deserted for the summer, and the shade of the campus's evergreens offered little respite from temperatures soaring into the upper nineties.

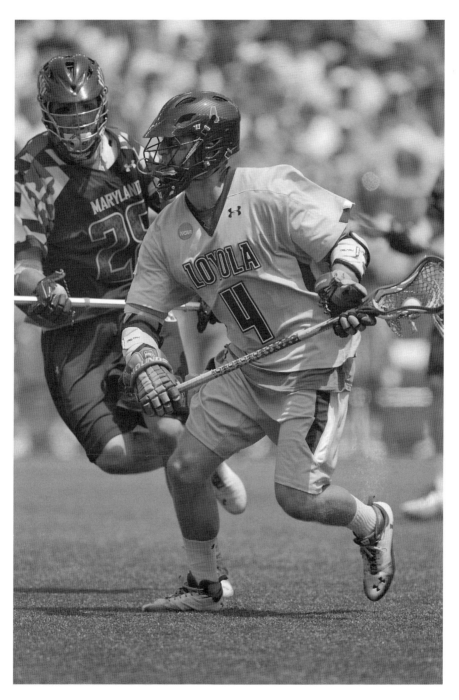

Charlotte native Mike Sawyer was a potent threat on offense for the 2012 Loyola Greyhounds. *Mike Broglio/Shutterstock.com.*

Maryland took a 3–2 lead early in the second when the Terrapins' Kevin Cooper scored, but Loyola came back and scored the next three, going into halftime with a 5–3 lead. Loyola lost thirteen straight face-offs, going back to its semifinal game, before finally winning one halfway through the second quarter. But the Greyhounds were still able to keep up the offensive pressure during the drought.

The Greyhounds' defense forced eight turnovers in the first half by Maryland, a team with a reputation for great ball control. The Terps did not score again after Cooper's goal. In the end, Maryland was held to just three goals through sixty minutes, and Loyola found the back of the goal nine times for a 9–3 win.

Eric Lusby of Severna Park High School had four goals for Loyola, giving him a record-breaking sixteen scores in four tournament games. Jack Runkel had six saves, and the Greyhounds' defense held Maryland to its lowest-scoring tally of the season. Charlotte-area native Mike Sawyer was a constant scoring threat on attack throughout the title run for Loyola.

For the first time in their history, Loyola players were the kings of the lacrosse world and the best team in Maryland. The *New York Times*, a newspaper that seldom features lacrosse articles, served up columns on consecutive days in honor of the accomplishment. Zach Schonbrun wrote the following in praise of the team in a column headlined "Loyola Soaks Up the Feeling of a Breakthrough Title":

> *The win for the top-seeded Greyhounds, the first national champion from the Eastern Collegiate Athletic Conference, represents a seismic event in the orderly recent history of the N.C.A.A. tournament, dominated in the last two decades by a small circle of programs.*
>
> *Now tiny Loyola, a Jesuit school in northern Baltimore without a Division I national title in any sport, can add its name to that rarefied list.*

"They've handled every situation with dignity and class this year," Head Coach Charley Toomey later said of his 2012 Loyola Greyhounds.

The 2013–15 campaigns saw the Greyhounds at a combined 33-15 mark. In 2014, the Greyhounds were back in top form. They won the Patriot League Championship in their first year in the league with an unblemished 8-0 record in league play. They also defeated Johns Hopkins in the annual "Battle of Charles Street" and advanced to the NCAA playoffs.

Defenseman Joe Fletcher earned his second straight first-team All-American honors, was named the Patriot League's Defensive Player of the

Jack Runkel was outstanding in goal for the 2012 Greyhounds. *Mike Broglio/Shutterstock.com.*

Nikko Pontrello (no. 18) and Justin Ward (no. 15) were forces on offense for the 2014 Greyhounds. *Tom Flynn.*

Year and topped that by capturing the William C. Schmeisser Award as the country's top defenseman. In the classroom, he was the Patriot League's 2013–14 Student-Athlete of the Year.

Justin Ward set the Patriot League's single-season assist record (fifty-three) in his only year in the league and earned the Patriot League's Offensive Player of the Year Award. He also garnered second team All-American accolades.

Despite each having only one year in the league, both Fletcher and Ward were later named to the Patriot League's 25th Anniversary Team in 2015. Fletcher, later in 2014, was named to the Team USA roster. In 2015, he earned Defender of the Year honors in Major League Lacrosse and was a key component defensively in the New York Lizards' title run. Ward helped man the Georgetown Hoyas' sideline in 2015 alongside his former goalie, Jack Runkel, as part of Kevin Warne's staff.

TOWSON UNIVERSITY

Towson University's picturesque Stephens Hall faces out onto York Road as the thoroughfare winds its way north from Baltimore toward its namesake city of York, Pennsylvania. The university was founded just following the Civil War in 1866 as the State Normal School, the first in Maryland. As with many Baltimore-area colleges, its original location was within the city's limits. In the case of Towson, it was located on Paca Street, near the current home of the University of Maryland's Baltimore campus.

"Normal school" was typically an early name for a teachers' college. Across the country, many schools experienced a similar, roughly century-long evolution from their initial mission as teaching institutions into universities. True to its original focus, Towson remains one of the country's top producers of teaching talent.

In 1935, it became the State Teachers College at Towson. By 1963, its name was shortened to Towson State College. In 1976, it took on university status and, by 1997, had settled into its current incarnation as Towson University.

The school has expanded exponentially and is now home to twenty-two thousand students and offers more than one hundred degree programs. It's also home to an exceptional lacrosse program. The Tigers' first win in their history came at the expense of the Brown University lacrosse club in 1959. They completed their initial season under Head Coach Bill Hooper with an overall 2-3 mark. Hooper led Towson for just one year and was followed in 1960 by Head Coach Bob Melville. Melville ran the Towson program

for four years, and his enduring legacy was boosting the club's permanence and expanding its schedule. In 1963, the team went 5-6, and its opponents included UMass, Loyola, Ohio State and Drexel.

Melville was followed first by Ross Sachs and then Dick Szlasa (1967) for one season. Szlasa's team went 6-3, and he later went on to great success at the Naval Academy. In 1968, Dick Runk assumed direction of Towson's lacrosse program. Under Runk, the Tigers continued Szlasa's groundwork and improved dramatically. In 1971, they went 13-1, and in 1974, they advanced to the NCAA Division II title game. They pulled out an overtime winner against Hobart, 18–17 for the national championship. They finished the season with an unmatched 14-1 mark, including a win over then number-four Division I Virginia, 18–14. They also cruised past local rivals Loyola, 26–6, and the University of Baltimore, 22–1.

That championship squad included three national players of the year at their respective positions. They were Jim Darcangelo at midfield, Bob Griebe on attack and Wendell Thomas as the USILA's top defensive player. Darcangelo and Griebe went on to play for the U.S. National Team at three World Championships and are members of the National Lacrosse Hall of Fame.

In 1980, Towson moved up in competition from Division II to Division I, and as with most competitive leaps, it was an adjustment. By 1983, the Tigers had effectively reset, ending the season with a 10-4 record and with the number-ten ranking nationally in the USILA's poll.

That year they didn't garner a berth in the NCAA tournament, but they did win the East Coast Conference (ECC). The ECC is a former Division I conference that dissolved in 1994; an unrelated Division II conference has since assumed the name. In 1989, on the strength of a 9-4 record that included a one-goal regular season victory over the number-one Johns Hopkins Blue Jays, Towson qualified for its first-ever Division I NCAA tournament. It was beaten by a North Carolina team that continued on to the semifinals before being halted.

The Tigers qualified for four NCAA tournaments in total in the 1990s. In 1991, they made their first appearance in the Division I national championship game, falling to UNC, 18–13. The Tigers knocked off Virginia, Princeton and Maryland en route to the championship, becoming the first unseeded tournament team to gain the final. Included on that roster was the nation's midfielder of the year, Rob Shek. Shek also garnered ECC Player of the Year accolades and was the program's first Division I First Team All-American.

In their decade of ECC play, the Tigers were the dominant entry. They won forty-four of their fifty-one league contests and also captured six of the ECC's ten titles.

In 1996, the Tigers joined the America East Conference (founded originally in 1979 as ECAC North, a men's basketball conference) and finished with a 5-1 league record and another berth in the NCAA tourney. They also finished the season ranked number fourteen in the country. A midfielder for the 1996 team, Tim Langton, became the second Towson player at the DI level to earn All-American honors.

Following the 1998 campaign, Runk retired. He left a 262-161 mark as his legacy, and former Hopkins and Penn head coach Tony Seaman followed him to the top spot. In 2001, Seaman led Towson to its best season of the 2000s with a 14-4 record. The team captured the America East title and gained the NCAA semifinals by dropping Division I heavyweights Duke and Maryland in the preliminary rounds. In the semis, Towson bowed to eventual national champion Princeton by one goal, 12–11. It was Princeton's sixth NCAA title in ten years after it, in turn, went on to knock off Syracuse by a single goal.

In 2002, Towson began play in the Colonial Athletic Association (CAA), where it still currently competes. It clinched titles in 2003, 2004 and 2005 under Seaman. The Tigers fell in two CAA finals in 2009 and 2010 by a combined total of four goals.

Seaman's tenure at Towson ended after the 2011 season. His list of accomplishments places him among the game's greatest company. His tutelage produced eighty-five All-Americans, and he registered 247 wins at his trio of Division I stops at Penn (1983–90), Hopkins (1991–99) and Towson (1999–2011). His teams reached the NCAA tournament nineteen times.

Seaman is the only Division I coach to take three different teams to the tourney, and he also led the U.S. National Team to a World Championship in 1994. The coach who began compiling accolades at Long Island's Lynbrook High School continued on to the Denver Outlaws of the MLL and currently is capping his career at one of Florida's top scholastic programs, St. Andrew's School in Boca Raton.

His successor was another New York native, Shawn Nadelen. Prior to pulling on Towson's black-and-gold head coaching cap, Nadelen enjoyed a long career in both the National Lacrosse League (NLL) indoors and the MLL outdoors. He spent his entire outdoor career with the Chesapeake Bayhawks franchise. As an undergraduate, he was a long-pole midfielder for Johns Hopkins. At Towson, he served for seven years as an assistant before

Senior captain and midfielder Justin Mabus brings pressure against Notre Dame in the 2015 NCAA tournament. *Towson University.*

taking over the top spot and was a member of the 2010 US FIL World Championship team.

Nadelen had his initial team at a 7-7 regular season mark in 2012 before falling to the then number-one and 14-0 UMass Minutemen in the CAA semifinals, 10–3. The next season, they moved to 10-8 and won the CAA title game over Penn State, 11–10. It was their first CAA title since 2005. They received the automatic qualifier for the NCAA tournament and exited in the opening round after a 16–6 loss to Ohio State.

In 2014, Nadelen's Tigers again had an overall winning record at 8-7. Included in their 2014 improvement were quality wins over Georgetown, Navy and UMBC.

They opened the 2015 season with a 7–5 home win against Johns Hopkins. It was the first time the Tigers bested Hopkins since 1996, and it fittingly announced a great season to follow. On May 2, in decidedly warmer weather, the Tigers claimed the 2015 CAA title when they beat UMass, 9–8, on a behind-the-back goal from senior Justin Mabus. With the win, the Tigers also earned an automatic qualifier to the NCAA tournament.

They registered an opening-round win against High Point, 10–8, and with the victory claimed their first NCAA tournament win since 2003.

Towson fell in the next round to number-one Notre Dame by a final score of 12–10. The Tigers finished the campaign with a stellar 12-6 mark and the promise of a successful 2016 season to build on its reputation as an annual CAA and NCAA tournament threat from the Old Line State.

UNIVERSITY OF MARYLAND– BALTIMORE COUNTY

B uilt into a sloping hillside in southwest Baltimore County, the campus of the University of Maryland–Baltimore County (UMBC) at times seems to develop its own microclimate. The school first opened its doors in September 1966 with three primary buildings. In the ensuing years, the cluster of dorms and campus buildings that has sprung up around them catch the prevailing wind and send it off in new directions with acquired velocity—fitting for a school considered one of the best in the nation for its scientific research.

On the lower portion of campus lies UMBC Stadium, partially protected from the elements and home to several university athletic programs, including the men's lacrosse team. It's here that the Retrievers host a steady stream of national lacrosse powers.

As an extension of the University of Maryland's main campus in College Park, UMBC was born with an immediate connection to the Terps' lacrosse tradition. The school opened its doors in the fall of 1966, and Dick Watts, a former Johns Hopkins All-American defenseman, began his tenure as athletic director in 1967. The development of a lacrosse team began quickly under the former Blue Jay, and by 1970, UMBC gained USILA sanctioning. By 1971, Watts was in charge of the team. He would see forty-eight of his players go on to earn All-American honors in the ensuing twenty-three years and would regularly win games that competitively should have been beyond reach.

In 1975, the Watts-led, non-scholarship Retrievers beat Syracuse (it was one of four consecutive wins against the storied program), as well as Navy

This 1980 UMBC team captured the NCAA Division II national championship. *UMBC.*

and Virginia. Without a formal stadium, the contests were often watched by fans finding space on a grass hillside adjacent to the playing field. That year, the Navy game was played in a steady downpour, as the Retrievers bettered the nationally ranked Mids, 10–9. Following the game, the Navy bus became mired in the mud above the hill, and a long day on the field became an even longer journey east back to Annapolis.

From 1974 through 1980, the Retrievers earned a spot in the NCAA tournament. UMBC was runner-up in the Division II NCAA championship to Adelphi in 1979. In 1980, UMBC won the national championship, turning the tables on Adelphi, 23–14, before an appreciative home crowd and a national television audience. It remains the Retrievers' lone men's lacrosse championship to date.

In 1986, still under Watts's direction, UMBC beat Princeton, Virginia, Cornell, Penn State and Georgetown in the same campaign.

The UMBC program was unique right from inception. In its earliest days, as a new campus with a limited social life, the school had its challenges in recruiting players to assemble a roster that regularly competed against top national teams. Watts turned to his primary recruiter, Charley Coker, to focus on players who were good athletes but were often overlooked or

playing out of position in high school. The strategy worked. Gary Clipp was a high school goalie who stepped out from the crease and became an All-American defenseman for the Retrievers, earning a spot on the U.S. National Team in 1982.

George McGeeney, whom many considered the best defenseman in America in his era, played on the 1986 and 1990 U.S. National Teams. He was a football player prior to arriving at UMBC. Rick Wey, another All-American, never had faced-off before becoming a Retriever. Under Watts, he became a force at the face-off X during his four years on campus in the mid-1970s.

The Retrievers moved to the Division I ranks in 1981. Although competitive with ten wins in 1991 and 1992, national rankings and NCAA tournament bids were understandably harder to come by at the higher level. Those years also included UMBC's Steve Marohl capturing the all-time single-season scoring record by posting 114 points in 1992. That mark held until the 2014 season. He is tied with Lyle Thompson for the single-season assist record with seventy-seven. Marohl achieved his seventy-seven in 1992 in three fewer games than Thompson.

Watts ended his tenure in June 1993 after twenty-three seasons at the helm but continued at the university as an assistant professor before moving on to Villa Julie (now Stevenson University). Finding a capable successor to Watts, who was later elected to the National Lacrosse Hall of Fame, was a challenge. Fortunately for the Retrievers, the ideal candidate was only a few miles away and part of Johns Hopkins University's storied lacrosse program.

UMBC selected Don Zimmerman who, like Watts, was once a former Hopkins All-American as an undergraduate. Returning to his alma mater as head coach in 1984, he led the Blue Jays to a national championship in his first year and repeated in 1985 and 1987. Zimmerman was a Baltimore native and attended St. Paul's School in Brooklandville, Maryland, one of the state and nation's top lacrosse high schools.

Zimmerman's move to UMBC in 1994 coincided with lacrosse continuing its ascent nationally, garnering larger crowds at postseason games and receiving more frequent, if still limited, television coverage. Keeping UMBC in the top tier of the lacrosse world would only become more difficult as many traditional powers grew deeper rosters than in years past. Traditionally strong athletic programs such as Notre Dame and Ohio State also put more emphasis and resources into their lacrosse teams.

In Zimmerman's first three years, victories were few, but in his fourth year, the Retrievers went 9-3. Then, in 1998 and 1999, UMBC made its first

appearances in the NCAA Division I tournament, losing by a single goal to Georgetown (9–8) and Delaware (12–11) each year.

The 1999 campaign included major victories over Navy, Cornell, North Carolina and Maryland. In its first two years in the surprisingly tough America East Conference (AEC) lacrosse competition, UMBC was knocked out twice in the league tournament. But from 2006 through 2009, UMBC won the AEC regular season and tournament championships in three out of those four years. "They believe in themselves…what you saw is a combination of some good talent, but great chemistry and a great attitude. I couldn't be prouder of these guys," Zimmerman said after UMBC's first America East Championship in 2006

For his efforts in 2006, UMBC's Zimmerman was voted America East Coach of the Year. The Retrievers' Brendan Mundorf, an Ellicott City product, was named conference player of the year. From 2006 to 2009, Zimmerman had the Retrievers back in the NCAA tourney four consecutive times. Losing to Princeton in the 2006 tournament only slightly tarnished a stellar 10-5 season.

In 2007, the Retrievers were co-regular season AEC Champions but lost the tournament championship by a goal. They still were invited to the NCAA tournament and, in the opening round, achieved one of the program's signature NCAA Division I victories, a 13–9 besting of the Terps.

The next year, UMBC once again returned to the tournament, losing a 10–9 game to second-seeded Virginia in Charlottesville. Four Retrievers from that team were named All-Americans.

In 2009, the Retrievers again bowed out in the tournament after a back-and-forth struggle, this time to the Tar Heels at Chapel Hill, 15–13. Although UNC was higher ranked, UMBC entered the game at 12-3 and had high expectations for a first-round advance.

In 2010, Mundorf and fellow attackman Drew Westervelt represented the United States in the 2010 FIL World Championships and helped the U.S. team earn the gold medal. Mundorf was named as a member of the All-World team following the tournament. Both players, along with former Retrievers Terry Kimener and Peet Poillon, have enjoyed very successful careers in Major League Lacrosse. In 2014, Westervelt and Mundorf were reunited in Maryland on the Chesapeake Bayhawks' roster.

MOUNT ST. MARY'S UNIVERSITY

Emmitsburg's Mount St. Mary's University—or "the Mount," as it's commonly known—sits twenty miles to the north of Frederick, astride Route 15 as the road makes its way to the Pennsylvania border. It's tucked just five miles below the border and fifteen miles from the famous Civil War battlefield of Gettysburg. The Mount was founded in 1808 as Catholics domestically continued a general migration to the state of Maryland. Pope Pius the VI earlier established Baltimore as the seat of the new U.S. diocese created in the late eighteenth century.

The college resulted from a confluence of events, including the purchase of a parcel of land near the town of Emmitsburg for English Catholics who came to the United States. Nearby was established a parish, St. Joseph's, with a mostly Irish Catholic population. Reverend John DuBois, a French immigrant who was a pastor in Frederick, founded Saint-Mary-on-the-Hill in 1805, drawing together the two groups. He also purchased a piece of land on which was founded a seminary. He was named its first president.

In 1809, Elizabeth Ann Seton arrived in the area with a group of young women and established a school nearer to the town of Emmitsburg. It would prove the first Catholic school for girls in the United States, and its presence helped populate the area and was a contributing factor in the growth of a Catholic presence in the region that also supported the Mount. Early graduates of the school included future cardinal John McClosky, who later founded today's Fordham University. Another graduate established New York's St. John's University in 1870.

Sports started to appear on the campus in the early 1870s as baseball's popularity spread. In 1891, the Mount faced Gettysburg in its first football game. In 1900, the school began to build Echo Field, much later the home of the lacrosse team. In 1916, the athletic offerings of the school continued to widen, and the men's tennis team played its first intercollegiate match. Babe Ruth visited the Mount as a member of the New York Yankees in 1921. As per the (suspect) legend, the Babe was discovered by the baseball world at the Mount years earlier when his St. Mary's Industrial School team came out to face the college's nine. A year later, the Mount became accredited, with a student body of 481.

From 1939 to 1945, more than seven hundred Mount students joined in the armed forces. Of that number, forty-eight of them were chaplains. With enrollment dropping in 1941 just as the United States was entering World War II, the Mount started a War Training Service for flying specialists. Still later in the war, in 1943–44, a navy V-12 deck officers school was established on the campus, and four hundred men helped repopulate it. It was by a similar means that Notre Dame stayed solvent during its lean war years, with much of its campus given over to training naval officers. In 1948, following the war, Memorial Gym was built and remains active today. A visit inside reveals a uniquely American field house reminiscent of the hundreds that dot towns in the Midwest.

A decade later, at the 150th anniversary of its founding, two prominent political figures from opposing political parties, Robert F. Kennedy and President Dwight D. Eisenhower, gave speeches at the school in honor of the event. The school became fully coeducational in 1973 following the merger with the nearby all-women St. Joseph College. In 1974, a women's basketball team took the court for the first time and the school's ascendency as a basketball program on both the men's and women's side began. By 1988, the Mount's athletic programs joined the ranks of Division I. In 1994, Knott Auditorium opened as the successor facility to Memorial Gym. In 2004, Mount St. Mary's College became a university, and in 2008, the school celebrated its 200th anniversary.

Lacrosse at the Mount started inauspiciously, with a winless 0-5 inaugural campaign in 1970, but that quickly changed. The coach for that first campaign was Randy Kilgore, and he remained the Mount's head coach for a total of twenty seasons. By 1973, he had the Mountaineers at 10-2 overall. During his time in Emmitsburg, Kilgore totaled 120 wins against 92 losses. In his last season at the Mount, in 1989, the team graduated up to the Division I level and went 7-4 in its first season at that tier.

Current head coach Tom Gravante has been a fixture at the top spot in the men's lacrosse program for nearly a quarter of a century. He spent his undergraduate years at Division III power Hobart College in the midst of its twelve straight NCAA titles. For a decade, Gravante held the record for the most goals in an NCAA tournament game (seven) and in an overall tournament (seventeen). He is a member of the Hobart Hall of Fame. "It's been an incredible experience," said Gravante. "Over my last 23 seasons, the Mount has become more than a place of profession for me, it's become home." During his time in Emmitsburg, Gravante has set the new standard with 134 victories through 2015.

Matt Warner lit up opponent goals in 2005 to post a new school single-season record with 50 scores. He is the Mount's overall record holder with 138 career goals, followed closely by Steve Ricker (137, 1997–2000) and Matt Mundorf (134, 1986–89).

In 2009, the Mount's goalie, T.C. DiBartolo set a program record with a 7.81 GAA while making 171 saves. In 2010, the team posted a stellar 12-4 mark in the inaugural Northeast Conference (NEC) title before bowing out to Virginia in the NCAA postseason at Charlottesville. The Cavs went on to come within a goal of besting the ultimate champion, Duke, that year. "I think it's real special to win the first one ever," Gravante said in describing the 2010 title. DiBartolo graduated after the 2011 campaign with 726 saves to establish the program's career mark. The Archbishop Spalding graduate went on to play for the MLL's Chesapeake Bayhawks.

The Mount is one of the smallest schools in all of Division I sports and played an especially difficult 2014 schedule that included Maryland and Johns Hopkins, in addition to Virginia. This was after the school had to replace its top ten point-scorers from 2013. "Our coaching staff across the board has the passion, the commitment and, most of all, the desire to win," said Gravante when asked about a turnaround. The Mount moved back up in 2015 toward its typical standards and the campaign included road wins over Hobart and Furman.

In 2016, the Mount will be a young team and with each new spring is a threat for the NEC title and beyond.

GEORGETOWN UNIVERSITY

While Georgetown University is located in the District of Columbia, it did spend a good portion of its earliest years as part of the Old Line State, as did the District prior to being partitioned from Maryland land. With its past physical connection to the state and a lacrosse history filled with many great Maryland athletes and opponents, it's fitting to include the history of the program here.

The area surrounding the university was initially laid out in 1751, and the construction of the Potomac Canal led to the development of the village of "George Town" as an important trade center along its banks. In 1789, John Carroll obtained the rights to sixty acres situated on a hilltop overlooking the bustling center. It was there that Georgetown was established by Maryland-based Jesuits as the first Roman Catholic college in the nation.

The school officially opened for classes in 1792 as Georgetown College. In its first year, the college's population grew to more than forty students, an auspicious start for the era. In 1814, Georgetown University first received its charter from the federal government. In subsequent years, it added a medical school (1851) and, later, its law school (1870).

The looming Civil War reduced the student body numbers from more than 300 to just 17 in the years of 1859–61 (the Civil War began in April 1861 and ended in April 1865). More than 1,100 students and alumni enlisted to fight, joining both sides of the conflict. After the Second Battle of Bull Run (Manassas) in 1862, some of the campus buildings were utilized as temporary hospitals. The colors representing the opposing sides of the

Civil War, the Union (blue) and the Confederacy (gray), were later chosen as Georgetown's official colors in 1876.

Patrick F. Healy, a Jesuit priest, was Georgetown's president from 1873 to 1882. Although he publicly lived as an Irish American, he was of mixed-racial heritage. As such, he was the first individual with African American ancestry to earn his PhD in the United States and also the first to lead a major U.S. university. Healy Hall, the iconic building on "the Hilltop" campus, was built during his tenure.

As Georgetown University progressed into the twentieth century, it continued to expand, adding a School of Dentistry (1901; it later closed in 1990), Nursing (1903) and Foreign Service (1919). By 1930, enrollment at Georgetown was at 2,600.

The Great Depression dropped enrollment below two thousand in the 1930s. Despite its economic hardship, in true Jesuit fashion it soldiered on and formally began its graduate school during the troubled decade. Since its modest beginnings in the eighteenth century, Georgetown has grown to a university of about twelve thousand students. It began accepting female students in 1969 and has been coeducational since.

As to lacrosse, the Hoyas' lacrosse program is not as old as some of the programs on the Hilltop, but it is growing longer in the tooth. Men's lacrosse made what amounted to a cameo appearance at Georgetown in 1951 but was hampered by a lack of funding. Despite what was an auspicious start, the team ceased operating after the 1952 season.

A decade later, two students, John Campbell and Roger O'Neill, and Georgetown alum Leo McCormick organized an intercollegiate team. It existed as a club sport in the spring of 1963, coincidentally the same time Georgetown's club football program—the forerunner to today's Division I team—was gaining traction. Like many club sports at universities, funds were sparse, and the team survived on the strength of its players and the committed volunteer efforts of early coaches. The Hoyas' coaches of that era included Tom Daly and Matt Kenny. The team's competitiveness and quality of opponents quickly improved as Ivy League schools, some with lacrosse programs rooted in the nineteenth century, soon appeared on the Hoyas' schedule.

The club moved up to varsity status by the end of the 1960s, and the school began play as an NCAA Division I program in 1970 (at the time known as the NCAA's "University Division"). In what is a familiar theme, it was former Johns Hopkins players who had a critical hand in getting the varsity program started—in this case Charles Goodell and Jim Feely.

Goodell saw the Hoyas through the 1970 season, posting a 2-6 mark, with their first victory a 5–4 win over Western Maryland (now known as McDaniel College). Jim Feely had little luck in the subsequent years, posting a total of four wins over three campaigns but helping to forge continuity as an NCAA program. The 1970s proved a fallow decade for victories at Georgetown, ending with no team compiling more than two wins in any one season.

The 1980s were a time of steady growth on the campus, and the decade also saw the creation of one of the most unusual playing fields in the country. The university's Kehoe Field was relocated to the top of the Yates Field House following its construction in 1979. Georgetown football, soccer and lacrosse were among those teams that took up residence on the artificial turf field built directly on its roof. Eventually—and hardly surprisingly—games were discontinued on the Yates rooftop due to structural problems.

It was during the 1980s that Georgetown's basketball team, playing in the original incarnation of the Big East conference, became one of the most accomplished in the country. The Hoyas lacrosse team improved in the win column, with five seasons achieving the four-win plateau (1980, 1981, 1984, 1987 and 1988). Still, they were lean years for the program; 1982 saw a 24–1 loss to Loyola, and in 1986 they went 1-13. The 1989 team closed out the decade and Head Coach Bill Gorrow's time at Georgetown with a program high of five wins, including a 9–7 victory over current power Notre Dame.

Dave Urick arrived in Georgetown in 1990 and with him the first winning season in the Hoyas' NCAA history. The 1990 team went 8-5 to begin a run of .500 or better seasons that would last as long as his time at Georgetown through the 2012 season.

Urick's accomplishments at Georgetown and prior are a task simply to list. Before arriving at Georgetown, he directed New York's Hobart College lacrosse for a decade and led it to ten straight Division III national championships from 1980 to 1989 (the Statesmen extended the streak to twelve following his departure). During that decade, he also led the 1986 Team USA squad to a gold medal at the World Games in Toronto. Before coaching, Urick was an outstanding lacrosse and football player at New York's Cortland State and later coached the Hobart Statesmen's football program. He then completed twenty-three seasons at Georgetown, compiling a 223-99 mark. His 1999 Hoyas advanced to the NCAA semifinals, the highest finish in the history of lacrosse at Georgetown.

One of the most historic wins in the life of the program was on May 22, 1999, at Hofstra Stadium in Hempstead, New York. The Hoyas

previously were 0-13 against the Duke Blue Devils, including a 10–8 loss earlier that season, and were facing them in the NCAA quarterfinals. Senior All-American Greg McCavera led the Hoyas' attack with four goals and two assists as Georgetown beat a 13-2 Duke squad by a 17–14 score. The win punched their ticket to a semifinal appearance at College Park against Syracuse and also secured the most single-season wins in program history with thirteen. Although the Hoyas fell to the Orangemen, 13-10, the campaign remains the most successful in school history.

In his combined thirty-three years of head coaching, Urick posted a .733 winning percentage and is a member of four Halls of Fame, including the National Lacrosse Hall of Fame. One of many players who earned All-American honors under Urick's direction was defenseman Brodie Merrill (2002–5), whose reputation as one of the best defenseman to ever play the game continues to grow.

Kevin Warne became the Hoyas' head coach in 2013, with large shoes to fill. Warne was selected for the job after making it to the Division I national championship game manning the sideline of the Maryland Terrapins as an assistant in 2012. In his playing days, Warne was an attackman at Hofstra, graduating in 1999.

In 2013 and 2014, the Hoyas finished at 6-9 and 4-10 in transitional years. Georgetown returned to winning form in 2015, posting a 10-6 mark and advancing to the finals of the Big East tournament. There it fell to the eventual 2015 national champions, the Denver Pioneers.

A Maryland product and key player for Georgetown in recent years was attackman Jeff Fountain (2011–14). Fountain is a native of the Lutherville/Timonium area and earned eight letters at lacrosse, soccer and hockey in high school while attending Brooklandville, Maryland's St. Paul's School. He attended St. Paul's from pre-K through twelfth grade and is one of countless Crusaders to continue lacrosse into the college ranks.

Of his time as a Hoya, Fountain said, "Playing at Georgetown was one of the best experiences of my lacrosse career. Not only was I fortunate enough to represent one of the most prestigious universities in the country, but I also played for a program that takes serious pride in what it means to be a Hoya." Fountain can claim an unusual honor that no other Hoya can: burying back-to-back overtime winners against the Navy Midshipmen in consecutive years (2013–14).

Today's Hoyas' lacrosse team plays at Multi-Sport Field (MSF), a level perch of land as the Hilltop campus ascends to its higher points. The field's capacity is presently listed at 2,500, with a fully built planned capacity closer

to 5,000. A striking feature of MSF in its current form is the large retaining wall that looms above the north end of the stadium. Adorned with "We Are Georgetown" in all capital letters, it is a prominent reminder of the host team and its continuing tradition of excellent lacrosse.

A review of Georgetown's past schedules as it grew from a club team to a prominent Division I program gives some insight into the fits and starts of college lacrosse's growth in years past. The Hoyas played both the Georgia Bulldogs and Georgia Tech in 1982, two teams that currently compete in the Men's Collegiate Lacrosse Association (MCLA) at the non-varsity level. They've since graduated on to some of the nation's best opponents in the reconstituted Big East.

Warne and his Hoyas are eager to continue the path set by Urick and go deep into the later rounds of the NCAA tournament.

OVERTIME:
GEORGETOWN ALL-AMERICAN GREG MCCAVERA

Greg McCavera was a standout member of several Hoyas teams that played during a great era of Georgetown lacrosse in the late 1990s. He shared some memories that define a distinct time and place in the evolution of Georgetown into a top-caliber Division I program.

ON THE QUIRKY ROOFTOP KEHOE FIELD:
You would have teams come up and play, and the wind would be howling and it would be as cold as anything in January, February and early March. There were dead spots in the turf. You'd take one shot and the ball would bounce up high; you'd take another and the ball would be dead and trickle into the goal. It was sort of like playing lacrosse on the moon.

ON PLAYING FOR COACH DAVE URICK:
Dave Urick was not a yeller or a screamer; he was very much a teacher. He's a big character guy, and if you're up there on Kehoe in January and February and it snowed, there wasn't a guy up there to shovel. Part of our practice was shoveling off the turf. It built the character of the team. It built a bond with the guys; we were really close.

ON THE WORKMANLIKE APPROACH OF GEORGETOWN PLAYERS:
My senior year of high school I was 125 pounds and five-foot-seven. I grew in college and when I left there I was five-foot-nine, 195 pounds.

There were a lot of guys that were like that. Guys that were good lacrosse players but might have been passed over by the Dukes, the Syracuses, the Marylands, for whatever reason. I think we had a bit of blue-collar, workmanlike attitude back then. When you came in as a freshman, you didn't get new equipment. You got equipment that was recycled and reused. We had a cleat bank. You got cleats that somebody wore the year before whether it was football or lacrosse.

On the hiring of current head coach Kevin Warne:
I think Kevin Warne is a great addition. He's very much like Dave Urick in his hardworking attitude. He brings intensity with him to the program. Kevin's a contemporary of mine; he played at Hofstra. A really great guy.

WASHINGTON COLLEGE

Those outside the state of Maryland may know little of its Eastern Shore, the peninsula east of the Bay Bridge between the Chesapeake Bay and the Atlantic Ocean. The "Shore" is bordered to the north and northeast by Delaware, and its southernmost tip is partitioned into a small portion of Virginia detached from the Commonwealth's mainland.

Tucked into the rolling hillsides of Maryland's considerable portion of the Shore, nearer to its northern end, is Chestertown. The once thriving colonial port town is home to Washington College, founded in 1782 and one of the oldest colleges in the country. The college's age closely corresponds to that of the United States as a nation and merits a mention of its own history before turning an eye to that of its lacrosse program.

As the Revolutionary War came to an end in 1783, Washington College graduated its first class in the spring of the same year. The college's founder, Reverend William Smith, had the radical notion for the times of educating "regular" citizens to become civic leaders and help the fledgling democracy prosper and grow. The reverend was born in Scotland, came to America in 1751 and served the College of Philadelphia (now the University of Pennsylvania) as its first provost in 1759. He arrived in Chestertown in 1780.

Within six months of arrival, he was placed in charge of the Kent County School, which had its own considerable history dating back more than a half century. The school expanded to 140 students under the leadership of Smith, and he petitioned for it to be granted a college charter. The state agreed, with a provision that Smith raise £5,000 within

five years to support the new college. Traveling on horseback, he traversed the countryside and raised more than double the amount required in just five months. The citizens of Maryland provided him with, as per the official Washington College account, "gifts totaling 6% of the currency then circulating in the state."

In his efforts to fund the new college, Smith persuaded General George Washington to donate fifty guineas (a British coin that circulated until the early 1800s and fluctuated in value). He also convinced General Washington to grant the college permission to use his surname as its own. The working name "the College of Chester" was replaced with the general's.

Washington's gift was the largest made toward founding the school. The general served on its board of visitors and governors for a five-year period before vacating that role to become the young country's first president. Smith was, in turn, the college's first president and, to its benefit, knew many colonial leaders of the era, readily raising funds and wielding influence in Annapolis. Washington College received Maryland's first college charter in October 1782. From that legacy, the college still flourishes as the tenth oldest in America and holds the distinction as the first chartered in the new, independent nation.

Shifting to its athletic history, the Chestertown region's most famous contribution to the sports world is Jimmie Foxx of nearby Sudlersville. The Hall of Famer known as "the Beast" spent time playing baseball in Chestertown, among other towns, as a member of the storied Eastern Shore League. He was signed from the league to the Philadelphia A's at the age of seventeen and was arguably Major League Baseball's best player of the 1930s. The best-known sports *team* from that region is the Washington College men's lacrosse squad. The Shoremen, as the college's teams are called, routinely rank among the best in the country in Division III.

Washington College introduced lacrosse in 1929. The team played five seasons until 1934, when the school, like many in the era, chose to drop the program during the lean years of the Depression. They were also lean years in the victory column for Washington College, as it won only five games in that initial six-year stretch.

In 1948, the program was reactivated by alumnus Charles B. Clark without the benefit of financial support from the school. Clark was a star for the struggling Washington College teams of the early 1930s and quickly shaped the program into one of the nation's best.

"The traditional 'Big Five,' which came into existence in the mid-'30s, virtually dropped out of existence. In its place came the 'Top Ten.' Into this honored group crept the name of institutions which had never been there

before, namely: Washington College of Chestertown, MD," read the 1950 *Lacrosse Guide* on the immediate impact of Washington College joining the USILA that year.

By 1954, the Shoremen were the USILA's Laurie Cox Division (or Division II) co-national champions. That team included John D. "Hezzy" Howard, a future Hall of Famer who played attack, took face-offs and led the nation in assists. Clark led the team for nine seasons and endured only one losing campaign during his tenure while compiling a 79-37 record. Midfielder Joe Seivold notched a place on the 1957 first-team All-American squad. To the same midfield was named all-time NFL great Jim Brown of Syracuse University.

In recent decades, the team has achieved its greatest prominence. In 1996 Washington College lost an 11–10 overtime Division III national championship game at Maryland's Byrd Stadium to Rochester's Nazareth College. The team faced the Golden Flyers again in 1997 and again fell in overtime, this time by a score of 15–14 to Nazareth at Byrd.

The Shoremen's spell of postseason bad luck came to an end on May 24, 1998, at New Jersey's Rutgers Stadium. The Shoremen had made the tournament all but three years since 1980 and were runners-up in the final seven times. The weight of history grew more oppressive with each passing year without a championship.

The Washington College Shoremen were 13-4 coming into the game, while Nazareth owned a 13-2 mark. The road to the final included a critical semifinal victory over Salisbury State, 12–10, after dropping Salisbury, 14–11, in the regular season in the two teams' annual meeting. Their coach was John Haus, a former Hopkins assistant. Haus was also a former two-time All-American at UNC and owned a 46-21 mark in Chestertown going into the championship game.

John Fuller was a junior on the 1998 team. In high school, his Boys' Latin Lakers lost consecutive MIAA-A finals to Baltimore's Gilman School. Arriving at Chestertown, the Shoremen then dropped two national championship games to Nazareth. Fuller certainly did his share to tip the odds in the Shoremen's favor. He was a first-team All-American as a sophomore, and the team improved significantly upon his arrival, reaching the Division III title game in each of his first three years.

On that day at Rutgers Stadium, under clear skies and before 14,609 fans, the Shoremen and Nazareth's Golden Flyers seesawed. Washington College held a 6–4 halftime lead after Andy Lopatin tallied the first three goals of the game for the Shoremen.

Nazareth went ahead in the third, 9–8, when Washington College lost three quick face-offs after its senior midfielder and face-off specialist, Greg Tomasso, went down with a knee injury. The Shoremen surged back to an 11–9 lead when Bill Grothman buried a twenty-five-yard shot with :44 left in the third. From there, Washington outscored Nazareth, 5–1, to seal the 16–10 victory and a national title. It was redemption for many players, including Fuller, who added three goals of his own despite playing on a sore ankle. Jamie Pollock added five assists and a goal from midfield. After the game, Washington College's Scott McGilvray and Jeremy Stoehr did a victory lap and together held Stoehr's no. 1 jersey aloft, indicating their place in the Division III lacrosse ranks.

John Haus said after the game, "At the beginning of the year, we talked about coming together as a team. It took this a group a little longer, but they pulled together, especially today." Andy Taibl was the winning goalie and told the *Baltimore Sun* after the game, "I came to Washington College knowing I'd be in a game with a chance to do this. I'm happy for this program, the faculty, teachers and coaches. They've been waiting for this for a long time."

The 1998 team finished with an impressive résumé: a 14-4 mark, a Division III national championship, seven All-Americans and nine all-conference selections on one roster. John Haus departed Chestertown for Baltimore and took the reins of Johns Hopkins in 1999.

J.B. Clarke followed Haus and had a very successful twelve-year run with the Shoremen. In 2014, he won a Division II national championship as the head coach of South Carolina's Limestone College.

Current head coach Jeff Shirk, son of the former standout New York Giants' tight end Gary Shirk, has continued the winning Washington College tradition. In 2014, the Shoremen posted an 18-2 mark and advanced to the NCAA semifinals. Shirk was recognized with Division III Coach of the Year honors. A 2001 graduate of Maryland, Shirk was an excellent short-stick defensive midfielder for the Terrapins.

The Shoremen compete in the Centennial Conference, one of college lacrosse's best small school leagues. Home games are held at Roy Kirby Jr. Stadium, and their chief rival is another Maryland Eastern Shore team, the Salisbury University Sea Gulls. The "War on the Shore" is the annual game between the Shoremen and Salisbury. Former coach Charles Clark, after a twenty-two-year absence from coaching, took the head coaching position at Salisbury College (now University) from 1978 to 1982.

In 2004, the winner of the game began receiving the Charles B. Clark Cup, and the rivalry has little parallel in intensity in the lacrosse world.

Overtime:
Washington College All-American Andy Taibl

Washington College goalie Andy Taibl is currently the athletic director and head lacrosse coach at Northern Virginia's St. Stephen's & St. Agnes School. He described his experience of playing for one of the nation's most storied lacrosse programs.

ON THE SETTING FOR THE 1998 NCAA NATIONAL CHAMPIONSHIP GAME AGAINST NAZARETH:

We'd lost to Nazareth twice before [1996, 1997]; both times were overtime games at the University of Maryland. 1998 was one of those Memorial Day weekends where it was pretty nice. Maybe mid-eighties and sunny. We were using about anything we could as a motivator for us, and the two times we played at Maryland were both kind of cool, rainy days. Different venue [Rutgers Stadium] and different setting, and we viewed it as a new opportunity.

ON BLOCKING OUT THE CLOCK EN ROUTE TO FINISHING OFF THE 16–10 WIN OVER NAZARETH:

I remember specifically in the third quarter, we'd come out of a timeout, and I talked to our defense and said, "Fellahs, I think we just put our visors down, don't look at the clock and let's just play." It was a one-goal game at one point, and I literally did not look at the clock for the rest of the third quarter into the fourth, and then with about four or five minutes left, I finally peered up and thought, "Holy cow, we're up by seven."

Obviously, a lot of credit on that day goes to our offense for being able to put up sixteen. It was certainly a good feeling after having gone through the others to feel like you kind of had it in hand down the stretch.

ON THE TRADITION OF LACROSSE AT WASHINGTON COLLEGE:

That was the thing that drew me there. My brother went there before I did, which is how I learned about the school and had the opportunity to watch teams play. He graduated in 1993.

Then I went there the following year. So it was not only the things our coaches did, but we were just proud to be part of a tradition. That to me was kind of the overwhelming thing that made me want to be there. You look at the history of that program and the names of the people that played there. And how they've been competitive in lacrosse since the beginnings of college lacrosse. Just being a part of that and putting on that same uniform

was like being part of the team that won our first championship—you can't really put it into words.

It was very emotional and an honor to be part of the program and then being part of something that I felt was very long-deserved for that school.

ON THE INCREASING SIMILARITY OF HIGH-LEVEL DIVISION III PROGRAMS IN COMMITMENT TO DIVISION I:
It didn't quite mirror Division I but was pretty close. Around then, it started to progress in that direction where we had extensive fall practices. We did winter team workouts and individual work. Then, by spring, we were obviously full bore.

DIII coaches that were really beginning to build solid programs were starting to tailor them after the Division I model of—for the most part— year-round activity.

Even in that time period, I felt like our coaches did a phenomenal job in their recruiting. We were able to get a good mix, some very skilled players but also very close or on the line of being a Division I athlete—that a lot of Division I schools would've liked to have had. Our opponents had it, too; obviously very good players are found at all levels, I, II, III. But athletically, Division III really started to take a jump, I felt, in that time frame. I think depth is one thing a Division I program has over a top Division III program.

I coach high school now, and we have a large handful of very talented, very skilled kids who get caught up in that Division I chase and I say, 'Guys, nowadays the opportunity is good across the board.' It's all about the experience you're going to have; it's about the opportunity you get to be part of a program and hopefully contribute.

ON THE ENJOYMENT AND IMPACT OF COACHING:
Our staff enjoys coaching for what we want to be the right reasons. We want to give these kids a great opportunity to play lacrosse. It might be something that would help them with a college decision. But at the end of the day, really using lacrosse to make them better young men.

ST. MARY'S COLLEGE
OF MARYLAND

S t. Mary's College of Maryland sits astride the St. Mary's River on a peninsula separating the Potomac River and Chesapeake Bay. It was originally founded as St. Mary's Female Seminary in 1840 as a boarding school for women. Although the school struggled initially to remain solvent, it solidified financially and administratively during the latter part of the nineteenth century and entered the twentieth in relatively good health.

Twice in the twentieth century—in 1924 and 1947—crises again challenged St. Mary's existence, one wrought by nature and the other by paper and pen. In each case, the community and the state rallied behind their "Monument School" (the name is derived from its place as a living monument to the birth of Maryland) to save it. In January 1924, during a harrowing blizzard, fire raged through and gutted the school's eighty-year-old Main Building, despite valiant efforts to prevent its spread. In its aftermath, St. Mary's supporters came together quickly to rebuild the school while the attending students made do by living in temporary quarters.

In 1927, the restoration effort yielded an additional payoff when St. Mary's officially became Maryland's first junior college. Its unique administrative structure gave students the opportunity to complete four years of high school and two years of college at the same institution.

It was threatened again in 1947 when the Maryland Commission on Higher Education slated the college for dissolution, although by that time

it was fully accredited and coed. Before it could be closed, there was a large public outcry prompted by the school's alumni and community groups. The school was ultimately saved from closure, and ample momentum gathered to remove the outdated "Female" from its name and rename it St. Mary's Seminary Junior College (1949). Less than two decades later, it evolved into a four-year public college (1967), and it became the present St. Mary's College of Maryland.

In 1971, Thomas Rowe, an associate professor of art, offered to sponsor men's lacrosse as a club sport. A charter was written and presented to the Student Government Association (SGA). The SGA granted the team club status and initially provided modest funding for equipment. The team obtained helmets and pads from the National Lacrosse Hall of Fame and began practicing with an assembly of largely inexperienced players.

Rowe sought the coaching services of U.S. Naval Academy alumni who were stationed at the nearby Patuxent River Naval Air Station (like St. Mary's, the base has gone by a number of different names) and who might have lacrosse experience. The 1960s Navy teams included some of the best in its history.

The club set up goals, laid out a field and obtained the coaching help of two test pilots, Roger Kisiel and Fred Lewis. Both men were former All-Americans at Navy. Rowe scheduled college B teams, prep schools and club teams once he had the help of the former Midshipmen in place.

The club team took the field that spring and began with a combination of college players and members of the St. Mary's College community. Lewis departed for a service tour after one season, while Kisiel continued to coach through the 1972 campaign, using his own funds to provide the team with jerseys and some meals. F-18 pilot Karl Volland, also based at Patuxent River at that time, joined Kisiel as an assistant, and in 1972, the team was added to the USILA's Division II.

In an atypical adventure for a small college with a new program, Rowe scheduled three games for St. Mary's in Miami during the 1974 spring break. While lacrosse has made dramatic inroads into Florida since that era, it could best be described as a remote outpost for the sport at the time. The appeal of Florida during spring break likely lent itself to the scheduling.

The next year, Volland was transferred out of Patuxent River, and the team was faced with the possibility of returning to club status without a head coach. Rowe learned that John Sothoron, a former All-American goalie and assistant coach at Towson, had returned to his native St. Mary's County. He was offered the job of head coach of the team and eagerly accepted.

During Sothoron's tenure, St. Mary's lacrosse solidified, the school became an NCAA Division III member and the team became an integral part of the college's athletic program. Sothoron directed the team as high as number eight nationally (in 1980), and during his tenure, it hosted both Duke and North Carolina State at St. Mary's and scrimmaged Syracuse. Following his time leading St. Mary's, he went on to found the lacrosse program at St. Mary's Ryken in southern Maryland's Leonardtown in 1989, where he is still head coach of the highly successful program. "Outwork everyone, overachieve and believe that you can accomplish anything," is the spoken credo of the lacrosse Hall of Famer.

The team posted a 7-6 record in 1991 and went 8-6 in 1992. The team captured the inaugural Capital Athletic Conference (CAC) lacrosse championship in 1993 as midfielder Dan Welch won 72 percent of his draws. The Seahawks followed up the first title with a second in 1994.

Former Seahawks head coach Chris Hasbrouck completed his tenure in 2015 after his seventh season. Arguably the program's highlight to date came during the 2013 campaign, when St. Mary's clinched the CAC title with a 13–11 victory over national powerhouse Salisbury. The watershed contest took place on May 5, 2013. The game was played at Salisbury, the Sea Gulls were the top-ranked team in the conference and they were also two-time defending CAC champions. From 1995 to 2009, they won fifteen straight league championships.

The Seahawks outscored Salisbury, 7–3, in the fourth for the come-from-behind win. St. Mary's erased a 10–8 deficit by finishing the game on a 5–1 run. The final score was 13–11, Seahawks. It was the program's first win over Salisbury in thirty-two years.

Crofton native Scott March had fifteen saves in the win for the Seahawks, and Mount Airy native Matt Tarrant scored four goals. "We came into the game with a lot of confidence, the team was playing very well and we were getting solid play in all three phases of the game, offense, defense and our specialty players. We also had great leadership from our captains, as well as a few other key players," said Hasbrouck later of the game. "We had a solid game plan, the players executed it flawlessly and they had a deep, unwavering belief that if we played together for 60 minutes we would win the game. To pull away in the fourth quarter and win the CAC title on their field was something none of those players will ever forget," he added. The memorable victory gave St. Mary's its third conference title and returned it to the top of the CAC ranks for the first time since nearly twenty years prior, in 1994.

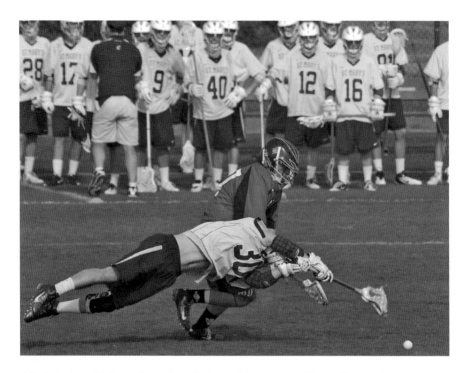

A St. Mary's and Mount Carmel grad Alex Brylske gives an all-out effort in a home game for the Seahawks in 2012. *Dan Wendell.*

Following the 2015 season, there was a change at the top of the St. Mary's program. Hasbrouck departed St. Mary's for Episcopal High School in the Houston metro area, in a state where the sport is booming in popularity. Under Hasbrouck, the team captured the CAC Tournament Championship title and earned the program's first-ever NCAA berth in 2013. It also was a solid 58-53 overall and 31-20 within the CAC. The team added five consecutive CAC tournament semifinals to its résumé from 2009 through 2013.

Jason Childs was recently announced as the new head coach. Childs is a native of Baltimore and in 2015 led Georgia's Division II Shorter University. He went 8-7 in the spring of 2015 in the team's first year as a full member of the NCAA. Before he was at Shorter, Childs served as the first head coach in the history of Mercer from 2009 to 2012. It was the state's first Division I lacrosse program in its history. Prior to that, he had a stint at South Carolina's Presbyterian College.

The Seahawks head into 2016 with a CAC title and an NCAA tournament on their list of targets.

McDaniel College

In 1865, following the end of the Civil War, a native New Yorker named Fayette R. Buell moved to Westminster and founded a coed academy while pursuing his larger goal of founding a college. He purchased land on a hill overlooking the town and distributed a prospectus to encourage and inform those interested in supporting the venture.

Funding came slowly, but Buell received major support from two community leaders. John Smith of nearby Wakefield Valley, and the president of the bustling Western Maryland Railroad, was one. The other was J.T. Ward, a Methodist minister. Ward later became the college's first president, while Smith took on the role of the first president of the college's board of trustees.

Smith offered free rail passage to everyone who attended the school's cornerstone ceremony. The first campus building, Old Main, was finished in September 1867. As per the U.S. Office of Education, "on the 4th of September, 1867, the first session of Western Maryland College was opened with 73 students and 6 professors."

The college distinguished itself from the outset by allowing access to all students regardless of race, gender, religion or nationality. It was the first coeducational college south of the Mason-Dixon line, at the time still a clear demarcation between northern and southern ways of life.

Western Maryland College remained the school's moniker until a much later incarnation of Western Maryland's board of trustees in 2002 made the decision to change its name to McDaniel College. Its namesake railroad had long since merged with another, forgoing its name in the process. This only

contributed to confusion regarding the school that led some to think that Western Maryland was a satellite campus of the University of Maryland or that it was located in the rural western portion of the state.

July 1, 2002, was the official name change date to McDaniel College and honored William Roberts McDaniel, whose sixty-five-year association with the college as student, professor, administrator, trustee, parent and grandparent "helped shape its mission."

Over the years the college has grown from the 73 undergraduates of the original class to 1,600 undergraduate and more than 1,500 part-time graduate students. McDaniel now has seventy-two buildings on its 160-acre campus and is home to students from across the country and the world. It also has a European campus in Budapest, Hungary.

With that historical backdrop, the lacrosse team began play in 1929 on the level grounds on its hilly grounds. That team went 3-3 under the direction of Tillman B. Marden. Western Maryland's lacrosse team fell victim to the Depression in 1932, aided perhaps by an aggregate 1-15 mark in 1930–32. It returned in 1948 and continued until 1954 before halting again.

Western Maryland's men's lacrosse team returned to the field in 1968 and resurfaced with a promising 5-1-1 record. Richard Clower's tenure began in 1969. Under Clower, the Green Terror, as the school's teams are known, posted an even 30-30 mark, including a 9-4 record in 1972 that was the program's best to date. That was bettered in 1974 when Richard Athey took to the team to a 12-6 mark.

In the intervening years before the Green Terror's next twelve-victory season in 2002, their all-time leading scoring emerged. Bill Hallett played from 1986 to 1989 and in those four years poured in 178 goals, while adding another 156 assists. Hallett added back-to-back All-American honors in 1988 and 1989. In one memorable 1989 game against FDU–Madison, Hallett set school records with 11 goals and 15 overall points.

The team was under Head Coach Keith Reitenbach in 2002 when it again reached twelve wins, notching a 12-2 mark. The year prior, the Green Terror went 11-4 and captured its first Eastern College Athletic Conference (ECAC) crown.

McDaniel lacrosse begins a new era in 2016 under Head Coach Keith Euker. He follows the successful tenure of Matt Hatton, a Hobart grad and former defenseman for the Statesmen. Euker played his undergraduate days at Loyola, graduating in 1999. He is also a graduate of Baltimore's Loyola Blakefield High School and is poised to continue McDaniel's competitive history in one of the nation's toughest Division III leagues, the Centennial Conference.

Overtime:
McDaniel College All-American Nick Sicuranza

After the 2012 campaign, two members of the McDaniel men's lacrosse team received All-American honorable mention—attackman DJ Rickels of Boys' Latin and defenseman Nick Sicuranza. Sicuranza is from York, Pennsylvania, and in his youth, he commuted across the state line to Maryland for lacrosse. He illustrated the away-from-the-limelight experience and work ethic of a stellar Division III defenseman.

ON WINNING THE 2012 ECAC TOURNAMENT HIS SENIOR YEAR:
That year, we made it to the Centennial Conference playoffs, and we lost to Washington College. After that, we played in the Eastern College Athletic Conference (ECAC) tournament, and we had home field advantage. We played two games at home and won it [13–9 over Marywood].

We didn't know until a couple of days after the conference playoffs that we were going to play in the ECAC. The captains were told as soon as we got home.

For the ECAC, it was mostly about the opportunity at the time to practice and play with the guys. Even if it wasn't the NCAA or winning the conference championship, it was good to go out with a win.

Another highlight of my senior year was beating Gettysburg; that was the first win over them since 1997 [seventeen total games].

ON PLAYING AT ONE OF AMERICA'S BEST SMALL COLLEGE STADIUM SETTINGS:
I think the grass bowl setting separates McDaniel. If you have a big day, like our Spring Fling or Senior Day, the grass hill gets pretty full. It was a great experience playing inside the bowl [Kenneth R. Gill Stadium]. The Weather Channel did a nationwide survey—Division I through Division III—of the best stadiums and tailgating experiences in the country, and McDaniel was in the top seven overall. It was a great place.

ON THE PRIDE OF THE McDANIEL DEFENSE:
We always came out in man defense, and we took our defense personally. If you're in man, that means you have good matchups and you think your team will have the better of it. If you came into the huddle, and the coach said, "We're going [into] zone," that means you weren't keeping up with them man-to-man. Of course, there were teams that you had to play zone against—they just had some shooters—but we typically played man-to-man with different slide packages.

Every year, we were put in the preseason conference ranks in the bottom few, regardless of what we had done the year before. Those things were definitely motivators. Coach would post the preseason ranks when they first came out in the locker room. You would look at that and kind of wonder, "Now wait a minute, we finished in the top four the last two years. Why do preseason polls ranks rank us 7, 8, 9 out of…8 or 9?" So we played with a little chip on our shoulder.

ON COMMUTING TO MARYLAND TO PLAY YOUTH LACROSSE:
I always joked that I graduated high school without ever playing high school lacrosse, technically, because it was always a club sport. I never lettered lacrosse for my high school [Dallastown]; the year after I graduated, it became a high school sport. I grew up driving to Maryland to play. When I was in elementary school, there were no teams for me to play on. I started playing in second or third grade, and I was driven down to play on the St. James Academy [Monkton] club team. I was attending St. James Academy for grades 6–8 and then went back to York for high school.

It's definitely got a different feel in Maryland. Kids that grow up in Maryland just have an understanding of the way it's supposed to be played—the flow of the sport. You can tell which kids truly understand that. That was the biggest difference coming down from Pennsylvania and playing teams.

Even though Gettysburg isn't a Maryland college, I know they had a big recruiting draw from the Maryland prep school area, and those kids and the way they are coached really helps them play at a high level.

ON MAKING ALL-AMERICAN:
I always had to work harder than the next guy. I'm a relatively athletic kid, but I'm not the most gifted athlete. I think coming into college, I set some really lofty goals. I got two out of three of them. I wanted to be All-American, I wanted to be All-Conference and I wanted to win a conference championship, which would have meant the NCAAs. I played about 50–60 percent of the games as a freshman and then started the three years after that. I really had to work for it.

I had a nickname from the staff members at the gym. I was always finishing up working out as girls' basketball was coming on. Through the grapevine, I learned I had the nickname "Stair-runner" because there's this loop in the McDaniel gym with stairs and I ran it every morning. I thought that was pretty funny.

I matured into the understanding of how hard you truly have to work to be successful. That was the mentality I carried into fall ball senior year and even into practice. For me, that meant I needed to work as hard as I could and that I needed to push myself farther than I thought I could every time I worked out.

I'm hoping to coach at some point as I had a great experience during my four years at McDaniel.

SALISBURY UNIVERSITY

The State of Maryland first began looking for a site for a new two-year teachers college on the Eastern Shore in the early 1920s. A location was settled on in Salisbury, and the school opened in the fall of 1925 as the Maryland State Normal School. Its original class was composed of 105 students, and its first president was Dr. William J. Holloway.

By 1931, the two-year program was extended out to a third, and by 1934–35 it was a four-year college. In 1935, Salisbury was given the right to grant a Bachelor of Science degree, and its name was changed to Maryland State Teachers College.

Just over a decade later, following World War II, the college expanded its academic offerings. They were expanded again in 1960. In 1962, the university was approved to offer master's programs and in 2012 offered doctoral-level classes. It took on the name Salisbury State College in 1963 and in 2001 became Salisbury University.

The Salisbury men's lacrosse program began in 1973 under Head Coach Andy Jones at the junior varsity level and became a varsity team in 1974. The Sea Gulls were winless at 0-6 in 1973 and quickly had a winning ledger in 1974 at 5-4. The program's first All-Americans arrived in 1975 along with a 12-3 record as Dave Cottle and Robbie White garnered honorable mention accolades. In 1976, Cottle achieved second-team status and in 1977 capped his career with first-team honors. By 1979 former Washington College player Charles Clark was leading Salisbury and had the team in the NCAA Division III tournament semifinals the next three years. Clark's tenure at

Illustrator Bristow Adams produced this classic 1905 image of a Hopkins lacrosse player. *Library of Congress.*

Edward Penfeld in the early 1920s later created a widely published image of a Hopkins lacrosse player. *Library of Congress.*

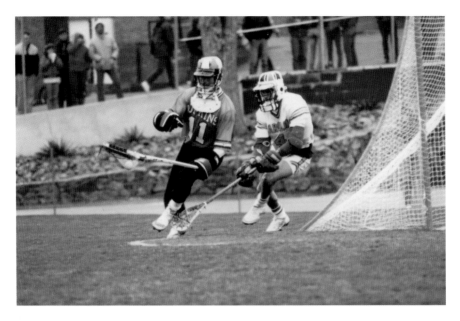

Quint Kessenich was an All-American goalie for Hopkins in the late 1980s. *Johns Hopkins University.*

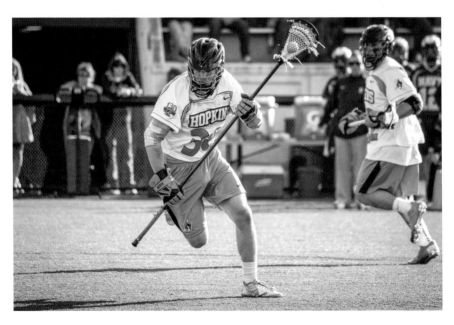

Johns Hopkins's defenseman Robert Enright in action against Navy at Homewood Field in 2013. *Dominic Castro.*

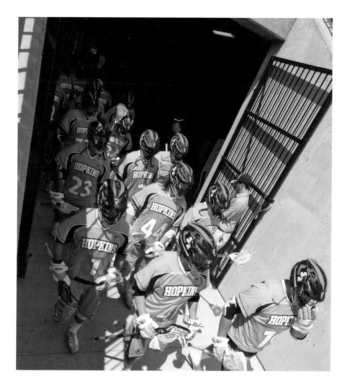

Hopkins exits the tunnel from beneath the Ridley Athletic Complex to battle Loyola in 2014. *Tom Flynn.*

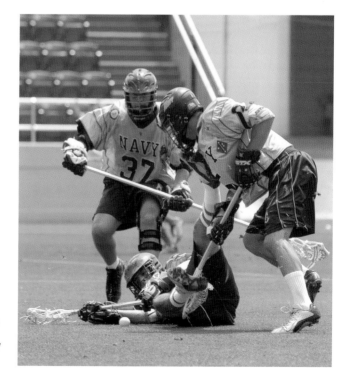

The 2004 Midshipmen surpassed all expectations and were one of many excellent Navy teams led by Head Coach Richie Meade. *United States Naval Academy.*

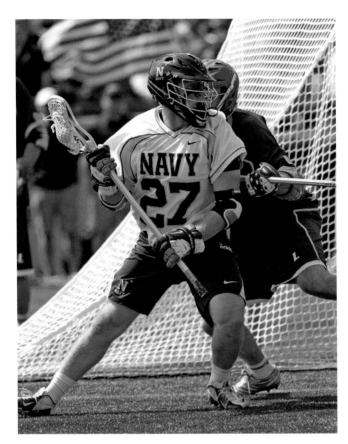

Left: Annapolis area native Sam Jones (2011–14) was a fearless attackman for the Mids in the early 2010s. *United States Naval Academy.*

Below: Washington College alum (1986) and Mids' head coach Rick Sowell exhorts his troops. *United States Naval Academy.*

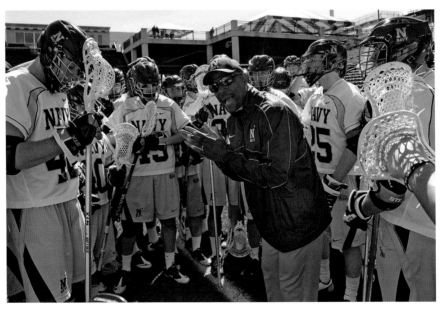

Right: Maryland's Goran Murray defends against Loyola in the 2012 NCAA National Championship. *Mike Broglio/ Shutterstock.com.*

Below: Loyola faces fellow Division I power North Carolina at home in 1992. *Bob Stockfield.*

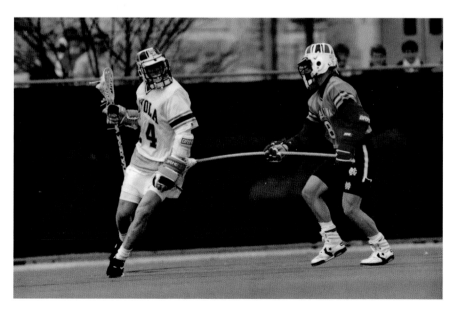

Loyola races onto the field after capturing the 2012 NCAA National Championship. *Mike Broglio/Shutterstock.com.*

The Greyhounds had their 2014 campaign halted in the NCAA tournament by co-Tewaaraton winners Lyle (no. 4) and Miles (no. 2) Thompson of Albany. *Tom Flynn.*

UMBC celebrates winning the America East Conference in 2006. *UMBC.*

Washington College midfielder Sid Looney works against Lynchburg in 2014; the Shoremen went 18-2 on the year. *Catie Hamilton/Washington College.*

Boys' Latin grad Stephen Luck (no. 4) celebrates with Baltimore's JD Campbell (no. 5) after a Washington College goal in 2014. *Catie Hamilton/Washington College.*

The annual "War on the Shore" between Salisbury and Washington College is one of lacrosse's most intense rivalries. *National Lacrosse Hall of Fame.*

Salisbury All-American midfielder Tom Cirillo lets rip in 2014 for the Sea Gulls. *Salisbury University.*

A Salisbury post-goal celebration is an annual harbinger of spring's arrival on the Eastern Shore. *Salisbury University.*

Stevenson went 18-3 in 2014 and gained the 2014 NCAA quarterfinals on the heels of its 2013 NCAA national championship. *Stevenson University.*

Zach Manzo is shown here on attack at McDaniel College's picturesque Kenneth R. Gill Stadium. *McDaniel College.*

Right: Ellicott City product Brendan Mundorf has excelled at every level of the game, including college (UMBC) and the MLL (Denver, Chesapeake). *Chesapeake Bayhawks.*

Below: Maryland native Ben Rubeor is an outstanding member of the Chesapeake Bayhawks. *Chesapeake Bayhawks.*

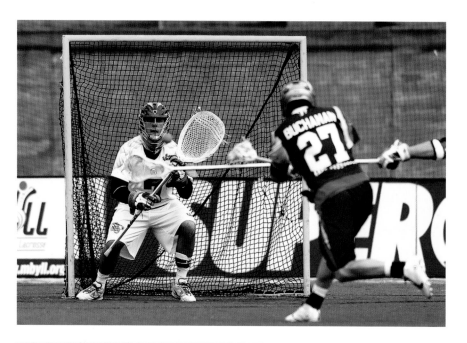

Above: Calvert Hall graduate Kevin Buchanan tries to beat fellow Marylander Tyler Fiorito in goal for the Bayhawks. *Chesapeake Bayhawks.*

Left: Former Johns Hopkins midfielder Matt Hanna was later an all-star for the MLL's Denver Outlaws. *Matt Hanna.*

Calvert Hall and Boys' Latin battle in an MIAA-A matchup. *Phil Romans.*

Bob Shriver compiled more than five hundred wins while coaching Boys' Latin for thirty-six years. He retired after the 2015 season. *Mary Carole Curran.*

Above: Howard County's Howard High School was runner-up in 2014 in the state finals and captured a 4A/3A state championship in 2015. *24 Seven Sports Photography.*

Left: Baltimore County's Hereford High School is consistently one of the top programs in the state of Maryland. *24 Seven Sports Photography.*

St. Paul's School is a top program in the MIAA-A and is shown here facing Boys' Latin in the 2014 title game. *24 Seven Sports Photography.*

St. James hoists its 2014 IPSL championship trophy after beating St. John's Catholic Prep. *St. James School.*

The sixteen-foot bronze statue *The Creator's Game* is stationed in front of the National Lacrosse Hall of Fame in homage to the sport's roots. *Tom Flynn.*

The National Lacrosse Hall of Fame holds the sport's greatest collection of memorabilia and information. *National Lacrosse Hall of Fame.*

Salisbury en route to its 1994 national championship victory over Hobart University. *Salisbury University.*

Salisbury helped set the bar for the high level of success that would follow as his teams went 43-19 over four years including a 14 win season in 1981. The Sea Gulls won 14 games again in the 1980s with a 14-2 record in 1984 under Head Coach Hank Janczyk.

Salisbury's accomplishments are largely without peer in NCAA Division III lacrosse history or at any level. The program's statistics of success read like a *Harper's Index*. The following are some from a much larger offering.

The Sea Gulls have won ten NCAA Division III championships and made 33 NCAA tournament appearances, including a string of 27 straight. The combined record of their ten championship teams is 196-5, for a .975 winning percentage. They've also earned nineteen Capital Athletic

Salisbury goalie Erik Miller makes a save for the Sea Gulls in a 15–9 victory over Hobart for the 1994 national championship. *Salisbury University.*

Conference (CAC) championships and compiled fifteen straight from 1995 to 2009. Salisbury also captured 105 consecutive conference games from March 1995 until April 4, 2009. The team has had 69-, 55-, 47- and 31-game winning streaks and, beyond that, rattled off an 87-game regular-season winning streak.

The list continues. Salisbury strung together an eighty-game home winning streak and in the years between 2004 and 2008 had five consecutive perfect regular seasons. Individual accolades for the Sea Gull program include 224 All-Americans, 44 national position players of the year and five national coach of the year honors. Salisbury has produced 11 MLL draft picks to date.

Head Coach Jim Berkman headed into 2016 with twenty-eight seasons behind him at Salisbury. He is the all-time winningest coach in college lacrosse history and was inducted into the Hall of Fame in 2013. The Watertown, New York native attended St. Lawrence University in his home state and was an All-American for the Saints and also a top-caliber basketball player. Berkman was the Saints' men's basketball MVP his junior and senior seasons.

When asked how he acclimated to life from upstate New York to that of Maryland's temperate Eastern Shore, Berkman said, "My wife, Jennifer, graduated from Cambridge High School and Salisbury. After living in upstate New York for four years and snowing on her birthday every year on April 20, I thought it was a pretty good idea to return to the Eastern Shore," said Berkman. Salisbury would agree.

The first national championship for Salisbury occurred when it beat the Hobart College Statesmen, 15–9, in 1994. First-team All-American Erik Miller was in goal for the Sea Gulls and was one of eight Salisbury players to garner All-American honors that year. Included was attackman Jason Coffman, who posted four straight years of first-team accolades. He also totaled an NCAA record 451 points in four years.

Hobart has since moved to Division I. The 1994 loss to Salisbury was the only championship game the Statesmen dropped in their NCAA Division III history.

Showing that the program is not diminishing with time, the Sea Gulls went 17-5 overall in 2015 and 8-0 in conference. They had three first-team All-Americans in 2015: senior Knute Kraus and juniors Thomas Cirillo and Preston Dabbs. The men's lacrosse Salisbury Hall of Fame entry in 2015 was Jeff Bigas, who graduated in 2005 after leading the team along with his fellow Sea Gulls to three straight national championships. He was the team's MVP in 2005 and was the National Defensive Player of the Year the same season. Bigas was a first-team All-American his final year.

Past tradition and current success are alive and well in Salisbury.

STEVENSON UNIVERSITY

Stevenson University, formerly known as Villa Julie College, first opened its doors on October 1, 1947. Founded by the Sisters of Notre Dame de Namur, the college was originally an all-female institution. The sisters were part of a Roman Catholic religious order begun by St. Julie Biliart in Namur, Belgium, in the late eighteenth and early nineteenth centuries. Villa Julie was sited on the grounds of an eighty-acre estate known as Seven Oaks in the winding Greenspring Valley just to the north of Baltimore in the unincorporated community of Stevenson.

Upon opening, students attended Villa Julie for one year of medical-secretarial training. Aside from the campus-like grounds, it was more akin to an independent business or secretarial school than a traditional college. That would change considerably in the following half century.

By 1954, its evolution had begun, and the college was approved as a true two-year institution by the State of Maryland. Villa Julie then received its first significant accreditation in 1962 from the Middle States Association of Colleges and Schools. It later took a significant step toward its current independent university status in 1967, when it established a board of trustees to oversee the school. With that change, it also ended its affiliation with the Sisters of Notre Dame and became a secular institution.

Villa Julie admitted its first male student in 1972, and its initial four-year degree programs were added a dozen years later in 1984. Despite the inclusion of bachelor's degrees, Villa Julie remained a commuter school with no residential units on campus.

In the fall of 1985, the Villa Julie College alumni publication *Ventures* boasted a record student body of 1,083 students that semester. By the spring of 1987, the school had its first four-year graduates; among the 11 pictured in *Ventures*, two were men. By the winter of 1988, men were listed as composing 10 percent of the 1,181 student body.

Lacrosse Hall of Fame member Dick Watts, who helped start the UMBC athletics program and coached lacrosse there through the 1993 season, turned his attention to jump-starting the fledgling Mustangs' athletic program as a consultant. With Watts's help, the Villa Julie athletics programs gained entry in the NCAA's Division III in 1994. Brett Adams was hired in the fall of the same year as the college's athletic director, a position he still held as of 2015.

A graduate of Carroll County's Liberty High School, Trey Shackelford, approached the school about starting a men's lacrosse team in what proved that same pivotal year of 1994. It competed as a club team that spring and compiled an 0-6 mark with a roster that had only several members with prior lacrosse playing experience. As goalie, Shackelford saw plenty of shots for the new team as it entered the 1995 season as a Division III varsity member. He starred for the 1995 and 1996 squads, and the Mustangs' men's lacrosse's most outstanding player award is handed out annually bearing his name. He led the nation in this senior year with 255 saves, including an astounding 32 against Wesley on March 26, 1996. Shackelford also excelled on the cross-country and was later inducted into the Stevenson Hall of Fame.

Watts was quoted in an April 1994 *Baltimore Sun* article as saying, "It's a much different world and a much slower pace than Division I schools with multi-million dollar budgets," he said. "You start with small expectations, just trying to get as many students involved as possible."

Haswell "Has" Franklin Jr. was a Hopkins lacrosse player in the early 1980s and later a member of the Mount Washington Lacrosse Club and an assistant coach at Loyola. Franklin was the first varsity coach of the Villa Julie program in 1995. Watts did not focus on a quick-winner but rather growing the programs over time, and Franklin successfully coached the team up from the club to varsity ranks.

Kevin J. Manning became president of Villa Julie in 2000, succeeding longtime president Carolyn Manuszak. He took up plans in earnest for a second campus located in Owings Mills. The student housing needs continued to increase, and zoning restrictions in Stevenson necessitated the college leasing apartments to students in nearby Pikesville and Towson since 1993. The Owings Mills campus became a reality and officially opened in August 2004.

In late 2007, as the school moved toward university status, there was a debate about whether to change the name to Villa Julie University or something that better reflected its current development and growth. Stevenson University was chosen as homage to the original campus location. Historically, a prominent Baltimore merchant named Robert Stevenson married Deborah Owings, a descendant of the founder of Owings Mills. The new name thus encompassed both a reference to the campus roots and a nod to its expansion.

In 2007, the school marked its sixtieth anniversary with the first Founder's Day Celebration on October 1. That same year, the men's lacrosse team continued to move dramatically up the Division III lacrosse ranks. Third-year Paul Cantabene led the team to a season-opening 10–9 win over defending national champion Cortland State at Owings Mills. Cantabene was a former All-American while an undergraduate at Loyola and was a member of the inaugural Baltimore Bayhawks team in 2001 and also a member of the storied 2005 MLL championship squad.

A six-game winning streak ensued before the team's first loss of the season to (then number-eight) Washington College. In 2007, the Mustangs earned their first Capital Athletic Conference tournament win, and although they fell short of the NCAA playoffs, they served notice with an 11-5 mark that they were a program on the rise.

Stevenson celebrates its NCAA Division III championship in 2013. *Stevenson University.*

On June 11, 2008, the board made the final vote to change the name of the college from Villa Julie College to Stevenson University. It also opened a business school that fall and continued to grow, largely on the Owings Mills campus. The campus was the former location of the Baltimore Ravens' training facility. Fittingly, in 2011, Stevenson opened a 3,500-seat stadium there and premiered its varsity football program. The football team won the home opener in double-overtime over Christopher Newport, 46–43, in its first game at Mustang Stadium. The game was a sell-out.

In 2013, the men's lacrosse team won its first NCAA Division III national championship against the Rochester Institute of Technology (RIT). The final score was 16–14 in the Mustangs' favor and was held at Philadelphia's Lincoln Financial Field. Stevenson finished the season with twenty-two wins against just two losses and a ten-game winning streak. It also had eleven USILA All-Americans and two scholar All-Americans.

It was the first national title in Stevenson history. Under Cantabene, the Mustangs went on to win eighteen games the following season. On the original Greenspring campus is a Mustang rearing its head with a green no. 47 in a yellow circle on its side. It's a reminder of how much it has grown academically and athletically since its modest start in 1947.

FROSTBURG STATE UNIVERSITY

Frostburg State University (FSU) is situated in the small western Maryland town from which it draws its name, some 150 miles northwest of Baltimore City. The university was originally founded in 1898 as a teachers' college after Maryland appropriated $20,000 in funds for the building of "State Normal School #2." (Towson University was the state's first.)

The location for the normal school was a two-acre plot of land known as Beall's Park, purchased by the town's citizens and provided to the state at no cost. Old Main, the campus's original building, was completed in 1900, and within two years, fifty-seven students were attending the initial classes of the State Normal School at Frostburg. The building remains today, still marked by its signature brick semicircular archways that for more than a century have protected its recessed entrance from the often severe Frostburg winters.

Those first students were enrolled in a two-year program, and by 1904, most received a diploma and a lifetime teaching certificate. By 1913, an elementary school opened on campus where students could gain teaching experience in a functioning school. There would be some form of an elementary school operating on Frostburg's campus until 1976.

Like most normal schools, Frostburg's name has changed frequently. It became the State Teachers' College of Frostburg in 1935, and by 1960, it had begun offering full four-year programs. By 1963, it was Frostburg State College, a name it held until 1987, when it was granted university status, leading to the current FSU designation.

During the evolution of Frostburg from a small teachers' college to its current status as a university with over 5,600 undergraduate and graduate students, it initiated a lacrosse program. The original team was short-lived, starting in 1970 and discontinuing play after the spring of 1978 and nine varsity seasons.

According to the school's media guide, records from that era are incomplete, but listed within as the leading goal-scorer for the 1970s teams is Paul Murphy (1972–75), who found the back of the net sixty-three times. Shady Lane, a player on the 1970–72 teams, led the early Bobcat lacrosse teams in total assists (fifty-two) and total points (eighty-seven). Opponents faced in the original nine years included Georgetown, Mount St. Mary's, UMBC and Towson among the better known.

The school announced its intentions to restart play in 2009, and the team took to the field as a member of the Capital Athletic Conference (CAC) in 2011. Head Coach Tommy Pearce, a Chestertown native and former All-American at Gettysburg, has been the only coach of lacrosse's second incarnation at Frostburg. "I am honored to be chosen by Frostburg State University to restart its lacrosse program," Pearce said at the time of selection.

He noted that a club team continued on campus after the varsity team was dropped in the late 1970s. "In the fall of 2010, when our recruiting class arrived on campus, we allowed club players to try out for the varsity team if they wanted to, but because I had a year on campus before our first year of competition to recruit, we brought in thirty-five recruits in that first class. So, we didn't wind up keeping many walk-ons," said Pearce.

In 2011, the Bobcats maintained a smaller roster so that they could focus on the young first-year players and leave ample room for a second recruiting class to fill out the ranks.

Pearce entered the 2015 season with a 35-39 career mark at Frostburg and with his team clearly on the right trajectory. After going a combined 8-26 in the first two seasons, the Bobcats went 13-7 in 2013 and 14-6 overall in 2014. In 2013, he garnered CAC Coach of the Year honors.

In 2013–14, Frostburg also made it to the Mid-Atlantic finals of the Eastern College Athletic Conference (ECAC), the "umbrella" conference to which many NCAA teams also belong. Both years it fell to Albright in the finale. The 2014 campaign saw the graduation of the most prolific scorer in program history, Pasadena native Ryan Serio. Serio rang up 180 points for Frostburg, including 114 goals. Attackman Devin Colegrave tallied 62 points for the Bobcats in 2014.

In 2015, the Bobcats had their best season ever. They were perfect through fourteen games and finished the campaign at 16-3 but fell in the CAC championship game to perennial power Salisbury. Devin Colegrave added seventy-one points for Frostburg to best his 2014 total.

GOUCHER COLLEGE

An assembly of Baltimore members of the Methodist Episcopal Church in 1881 decided to build an educational institution in commemoration of the church's centennial, specifically a seminary. The project initially failed to gain traction within the ranks, as some had concern that the modest scope of the proposed seminary would diminish the commemorative notion. Others proposed a different project altogether: a college.

Within the assembly, Dr. John Franklin Goucher and his wife, Mary Fisher Goucher, were vocal proponents of a college, specifically a women's college. Goucher was a minister within the church and had experience playing a role in the forming of other institutions within the state, including Morgan State University (originally named Centenary Biblical Institute).

The idea gained traction and came to fruition when the institute opened as the Women's College of Baltimore City in January 1885. In 1910, it was renamed in honor of the Gouchers. Originally the campus was located at the lower end of the area now known as Charles Village at the intersection of St. Paul and Twenty-third Street and featured suitably impressive buildings for a centennial.

Following the pattern of Towson and Loyola, the college eventually migrated north from its original location. In 1953, it moved to its current home in Towson, forgoing Romanesque architecture for open space, rolling hills and greenery. The buildings it left behind became the center of what is now the picturesque Old Goucher College Historic District in Baltimore City. The new campus was so well laid out that in 2007 it garnered its own

historic district designation. The student body is currently about 2,500, including graduate students.

In 1986, it enrolled its first male students, and in 1992, it fielded its first men's lacrosse team. The Gophers—as the college's sports teams are known—took the field under Head Coach Steve Hornish, a former All-American defenseman at Towson University.

Hornish established the team in the Division III Capital Athletic Conference (CAC), staying at the helm for four years and moving the high-water mark for wins to five. He was followed in Towson by Jim Lyons, who ratcheted the all-time win mark to seven (1997, 2000) as the team steadily made progress toward .500, finishing at 7-8 in Lyons' last year in 2000. In 2001, Head Coach Kyle Hannan arrived with an exclamation mark from Colorado College. In his playing days, Hannan was a four-year starting midfielder for Salisbury in the mid-1980s (1983–86). His scholastic playing days were spent at Baltimore County's Franklin High School.

His first-year team went 13-3, and the team posted only one sub-.500 season in his dozen years leading the Gophers. He compiled a 129-71 mark during that time and oversaw the transition of the program to become a founding member of the Landmark Conference based in Madison, New Jersey, home of the Drew University Rangers program. In 2012, his final year at Goucher, he led the program to an 18-2 record. In his last campaign in Towson, the Gophers beat the typically powerful Washington College program in the first round of the NCAA playoffs.

He departed to take over a Mercer University Division I program with only two years of NCAA competition in its program's history. By his second year, in 2014, Hannan had Mercer to .500 with seven wins and has the program on an upward arc.

With Hannan's departure, the top offensive assistant coach at Goucher, Brian Kelly, stepped up to take over at the helm. Kelly got his college start at CCBC–Essex, Maryland's perennial power at the junior college level. He helped the Knights to an NJCAA national championship in 1991 and garnered second-team All-American honors. From there he moved on to Johns Hopkins, and while he was there in 1992 and 1993, the Blue Jays reached the NCAA semifinals each year. Kelly was an honorable mention All-American at Homewood and in 1993 earned the Turnbull-Reynolds Award, given annually to the Blue Jays' player who displays outstanding leadership and character.

In his debut season, Kelly led the Gophers to a perfect 6-0 record in the Landmark. In 2014, he had the team at an overall 7-7 mark, and under his

Although one of Maryland's "newer" teams, the Goucher Gophers have quickly ascended in the Division III ranks. *Nony Dutton*.

guidance, Pierce Ingram—an Austin, Texas product—became the eighth player in Goucher history, and just the second midfielder, to be named All-American. Ingram was exceptionally well rounded as a middie, posting twenty-eight points on twenty-one goals and seven assists. He also was credited with thirty-three ground balls and five caused turnovers. "He meant so much to our team, particularly the past two years, and it was an honor to coach such an outstanding young man," Kelly said at the time of the announcement.

Kelly is ready to lead the first senior class guided entirely under his stewardship into a successful 2016 campaign.

HOOD COLLEGE

Hood College was founded in May 1893 as the Women's College of Frederick when five members of what was then the Reformed Church established an independent college. The goal was to prepare women for roles in the home or workplace, and the curriculum was a liberal arts education deemed as the best preparation for a productive life.

The five men who composed the board were four local men along with John Roller of Harrisonburg, Virginia. The college's first home was in downtown Frederick, and it remains today close to the city's center. It opened on September 12, 1893, with eighty-three students and eight faculty, and the College's first president was Joseph H. Apple. It became coeducational just under a century later in 1992, and its men's lacrosse program began play in 2005.

Program firsts include a first season of seven games for the Blazers and a first program victory in early 2009 when they beat Gwynedd–Mercy College, 12–7, at home. Sophomore goalie Nick O'Brien made a career-high fourteen saves in the win. The year 2010 saw more improvement, as the Blazers notched six wins, including their first three-game winning streak early in the campaign. In 2011, the high-water mark for wins moved up to eight, and Kris Miner deposited twenty-six shots in the back of the goal for Hood.

A new chapter began at the college when Frederick's own Brad Barber was elevated to the top job at Hood in July 2013. Barber played as an undergraduate for Division I Robert Morris. When he got the nod for the top job in Frederick, he was just twenty-three years old and tied for the youngest coach in Division III at the time. Barber is the eighth head coach

in the Hood program's history. He was an outstanding player in high school at Frederick's Tuscarora High School. Prior to taking the top job at Hood, he was an assistant coach there and was also active at the youth and high school club levels.

Hood graduated in 2015 the best defenseman in the school's short eleven-year history. James Weger was the all-time leader in caused turnovers with 177, and he ranks second in the program's history in ground balls. Hood College competes in the Middle Atlantic Conference (MAC), in existence since 1912. They head into the 2016 season with a host of talented players including junior midfielder Patrick O' Brien, who had 15 goals in his sophomore campaign. With Frederick Community College adding a lacrosse team in 2016 and the promise of local and distant talent, the Blazers' prospects for success in the second decade of the program continue to rise.

MARYLAND'S COMMUNITY COLLEGES

Maryland community colleges play in the Maryland Junior College Athletic Conference (MDJUCO), established in the late 1960s. It presently has an overall membership of sixteen teams. Of those, seven compete in lacrosse.

For years, the University of Baltimore was an upperclassmen level–only institution and received a steady supply of lacrosse players from the state's junior college ranks. They include the Community College of Baltimore County (CCBC)–Essex, Howard Community College, Anne Arundel Community College, College of Southern Maryland, Cecil College, CCBC–Catonsville and Harford Community College.

In March 2015, Frederick Community College announced its first men's lacrosse coach. Salisbury graduate and former Middletown High School head coach Todd Hawkins got the nod and will be leading the Cougars into action in the spring of 2016. "Having a lacrosse team at FCC will fill a gap for so many of Frederick County's talented high school players," said Hawkins upon taking the job as the head of Maryland's newest men's college team.

MDJUCO is part of the larger National Junior College Athletic Association (NJCAA). The NJCAA is currently composed of thirty-four teams in men's lacrosse. The reigning national champ is New York State's powerful Onondaga Community College. Maryland's top threat to unseat the Lazers is CCBC–Essex, led by Head Coach Shawn Burke.

Essex has claimed twenty-eight MDJUCO titles and also two national championships, in 1991 and 2004. Next in the overall power rankings within

the state are typically Anne Arundel and Harford. From 1991 to 1994, Anne Arundel was led by former Maryland great Bud Beardmore. In 1992, he coached alongside Alan Pastrana, a former Maryland and NFL quarterback as well as a lacrosse All-American. Few sidelines in history have boasted such an accomplished set of coaches. Anne Arundel later captured the lacrosse junior national championship in 1998.

Numerous Maryland junior colleges players have launched from that level to prominence in the collegiate and pro ranks. They've included Kyle Hartzell (Salisbury, MLL). CCBC–Essex graduate Zach Thornton traveled from Essex to earn All-American honors both as a goalkeeper for the Loyola Greyhounds and an All-American midfielder for its lacrosse team in the mid-1990s. Sean Heffernan and Andy Martin went on to successful careers with the Greyhounds. Brian Kelly is another successful Maryland junior college product, going on to Johns Hopkins and now the successful head coach at Goucher College.

Peet Poillon is a graduate of Howard Community College who went on to star at UMBC and was part of the midfield of the Chesapeake Bayhawks that won the 2010 MLL Championship.

Near the Turnbull Trophy at the National Lacrosse Hall of Fame is a display of the Devine Cup, a now-retired prominent silver bowl that was once awarded to the nation's best junior college player. Perhaps in future years it will return to active service and provide the junior college ranks with a historical equivalent of the Tewaaraton.

FORMER COLLEGE PROGRAMS

ST. JOHN'S COLLEGE

St. John's College of Annapolis is a short distance from the Naval Academy and has roots extending back to the founding of King Williams School in 1696. Although it presently has no varsity sports, they once were an integral part of the well-rounded student experience in the 1920s and 1930s. The team efforts of Head Coach Dinty Moore and the "Johnnies" are included in the descriptions from the era for Johns Hopkins, Navy and Maryland.

Individually, St. John's College produced an unusually large number of all-time greats despite its relatively short existence as a team. One member of the St. John's College teams who earned his way into the National Lacrosse Hall of Fame was John W. Boucher. Boucher hailed from western Maryland and attended Grantsville High School in Garrett County. Prior to arriving in Annapolis, Boucher never saw a football or lacrosse game.

Nonetheless, he lettered in football in three of his four years as a Johnny, played in the first lacrosse game he ever watched and also played every minute of every St. John's lacrosse game of his career. He was a 210-pound defenseman and was a member of the 1929 St. John's national championship team. He went on to coach from 1931 to 1933 at Maryland's Tome School, where he led the swimming and lacrosse teams and was an assistant for the football team. He played both professional football and lacrosse, including a stint in 1931 as a member of the Cornwall Colts of the Canadian Professional Box Lacrosse League.

Another St. John's great was Andrew Kirkpatrick of Granite, Maryland. Kirkpatrick graduated from Baltimore City College and, like Boucher, went on to play both football and lacrosse at St. John's. He was a captain of the football team (and an All-Maryland selection) and later played for Mount Washington and the L'Hirondelle Club. He later coached lacrosse at Baltimore City College. Like Dinty Moore, he was a contributor on the sport to newspapers, including the *Baltimore News-American*.

MORGAN STATE UNIVERSITY

Morgan State University sits on 143 acres in northeast Baltimore on East Cold Spring Lane, several city blocks above the city's historic Lake Montebello. It was founded by the Methodist Episcopal Church in 1867 and originally was located at the city's Sharp Street Methodist Episcopal Church. Originally known as the Centenary Biblical Institute, it was renamed to honor Reverend Lyttleton F. Morgan, the chairman of the school's board of trustees from 1876 to 1886, as Morgan College in 1890. In a familiar pattern of higher-education institutions in the city, it migrated north in search of space.

The iconic, century-old Holmes Hall both serves as a centerpiece of the current campus and a symbol of the university. Morgan was a private institution until 1939, when it became Morgan State College. In 1975, it was renamed Morgan State University as its academics expanded to the masters and doctoral levels.

Morgan is a historically black institution, part of a larger group of colleges and universities known collectively as Historically Black Colleges and Universities (HBCUs). Its current population is roughly 6,000 students at the undergraduate level and 1,200 at the graduate and doctoral levels.

Morgan State's lacrosse history began roughly a century after the founding of the institution. In the fall of 1969, Miles Harrison Jr., a sophomore and former attackman for Baltimore's Forest Park High School, began gathering interest for a lacrosse team at the college. The head of the football team at the time was Earl "Papa Bear" Banks. Banks asked Chip Silverman, who was an assistant dean at Morgan, to be the team's coach.

The team competed at the club level the following spring in 1970 and in 1971 became a varsity-level team, lasting through the 1981 season. Harrison—who later became a surgeon and whose son, Kyle, went on to win the Tewaaraton Award as a midfielder for Johns Hopkins—was integral in

Morgan State's prowess in lacrosse in the 1970s and early 1980s far exceeded the age of the program. *National Lacrosse Hall of Fame.*

establishing the Bears. Along with Silverman, he later wrote the book *Ten Bears* about the team and the era.

The team played in the spring of 1970 against local clubs and freshman teams. The next year, in 1971, it entered the NCAA. The Bears went 8-4 in their inaugural season. Harrison played in the NCAA's North-South Game following the campaigns. The Bears were ranked nationally in four of their first five years in Division II and in 1975 shocked the lacrosse world by winning their opener over Washington and Lee, a team that hadn't lost a home game or regular season game in the prior three years.

Silverman stepped aside as coach after the 1975 season and was later inducted into the university's Hall of Fame in 1991. He passed away in 2008 at the age of sixty-five. The school cut the program in 1980, ostensibly due to a lack of funding, although the perception among players and university lacrosse supporters was that there was a lack of administrative support. During its tenure, the team's victories included triumphs over Georgetown, Villanova and Notre Dame, among many other programs.

Lloyd Carter was a native Baltimorean and attackman for the last Morgan team in 1981. Prior to arriving at Morgan, Carter was an All-State

attackman and middie at the city's Edmonson High School. He coached for an extended period after his college career at several stops, including a long and successful tenure as the head lacrosse coach at Baltimore's Northwestern High School. He also led the Morgan State club-level team from 2004 to 2008 and founded the Blax Lax program to promote diversity in the sport at the college and high school levels. The organization competed for ten years.

Carter's next step will be a historic one when he fields the first Division I HBCU team in history at Virginia's Hampton University. The team is scheduled to begin with the spring 2016 season. With the start, Carter continues the Bears' legacy and furthers the inevitability that more HBCUs will be joining the college lacrosse ranks.

Overtime: Former Morgan State Bear and Current Hampton University Head Coach Lloyd Carter

On high school and Morgan State:

I played at Edmonson High School until 1976. At Morgan, my first season was 1977. 1981 was the last season we played.

My junior year of high school, our coach took us to camp at the University of Maryland the year they won the championship in 1975. I still remember Frank Urso, Gary Glatzel—all those guys. So we went to their camp, and I thought, "Oh, this is how you really play," because before that I was fairly athletic and could pick the ball up and run and dodge and shoot. After that, we really understood how to catch and throw.

When we got to Morgan, we had a lot of talented players from the city—Calvin Slay, Mike McBride and defenseman Rodney Early. Donnie Brown, too, he came out of City College. We were an incoming freshman class, and we were at a different skill level. Joe Fowlkes was already there and a superior athlete. We learned to go from a fairly transitional team to one that could play a half-field set, and we could really settle the ball.

On developing the game in Baltimore City:

After Morgan, I played club ball for a while. Then I started coaching at Northwestern. I started to get some really good talent. I had probably one of the best players to come out of Baltimore, probably to come out of Maryland—Shawn Medlin. He played in the senior all-star game (2001), the same senior all-star game that Kyle Harrison played in. Shawn ended up

winning the MVP, and he was on the losing team. He was getting recruited to go nowhere. I thought, "That can't happen again."

So we started an inner-city program called Blax Lax. When we started that, my main goal was to improve the opportunity for inner-city kids to go to college. To build skills and, at the same time, spread the game of lacrosse in the inner city.

ON HOW HE ARRIVED AT HAMPTON:
There was a student at Hampton, Michael Crawford, who founded a club and died his senior year, and his parents wanted to keep his legacy alive. Verina, his mother, Googled "black lacrosse," and my name came up. So that's how we met over the phone, and we had a conversation about a program and it was really emotional. I told her God had her call the right person. So I started commuting down there every weekend and kept the program going.

I would practice at Northwestern Monday to Thursday. I worked with my athletic director to head down there on Fridays. So for about two years I went down there almost every week during the season, to get the team up and running.

I had thirty years in the Baltimore City Fire Department. I was a deputy chief, and my specialty was emergency medical services. When I retired, I always wanted to pursue teaching EMS; I wanted to become a professor. So because I'd been coming down for the club team, I was familiar with the area. I was looking for teaching positions for EMS, and Hampton popped up and I thought, "Wow," so I came down here for that position.

Since I was down there, I walked over to the gentleman who'd taken over their club team and asked if I could come and help out, and he said, "Help out? You can come over and start coaching." So I came back, and I was coaching about two years when the Division I NCAA talk started. In May [2015], they made the announcement.

ON ADJUSTING TO THE NEXT LEVEL:
Hampton is very strong academically and it's a phenomenal campus. People come here for academics first, and for the past few years it's been, "Oh, by the way, we have a club team." My main approach is primarily getting their lacrosse IQ up. Some of the club players had never played before they came here. The good thing about this program is, I'm able to move my club team right over. So 80–85 percent of my players I've coached over the last two years.

So they know each other, they know how I coach, they know how I approach the game. Now they're just developing skills and developing confidence in playing. Our defense is probably our strongest aspect.

Our midfield play is very athletic, very fast, so between the restraining lines we can compete with anybody. Our real focus going forward is going to be solidifying the offense and getting guys to learn how to finish. Last year, we played a pretty competitive club schedule, and we outshot everybody we played. Except we just couldn't finish. That's a natural progression in lacrosse—guys learning how to put the ball in the net as opposed to shooting at the goal. That's going to be the focus going forward with this particular group.

University of Baltimore

The University of Baltimore (UB) had the most longevity of the any of the state's former four-year college programs. The university was founded in 1925, and a UB lacrosse team appeared in the *Lacrosse Guide* later that same

The University of Baltimore was founded in 1925 and shortly thereafter began its lacrosse program. *Lacrosse Guide.*

decade. It appeared again in the 1933 *Lacrosse Guide*, with its team posed at Baltimore Municipal Stadium.

The heyday of the program was likely in the late 1950s, when the team won four consecutive USILA Laurie Cox Trophies for its Division II championship. From 1953 to 1959, the USILA split into three divisions and rotated members based on their accomplishments when they won consecutive championships in 1956–59.

Dick Edell coached UB from 1973 to 1976 and was followed for one year by Chip Silverman. Silverman agreed to take the post for one year, as Edell departed for West Point to lead the Cadets before returning for a tenure at the top of Maryland's program.

The 1982 team posted an 11-2 ledger under Richie Meade, who went on to a highly successful tenure at the Naval Academy. UB ended its intercollegiate sports programs after the 1983 season. Two players from the men's lacrosse program were recently inducted into the UB Hall of Fame, Steve Kopf (1979) and J. Donald Willoughby (1961). Their addition is further evidence that although the lacrosse program has ended, its history remains an important part of the life of the university.

OVERTIME: CURRENT FURMAN HEAD COACH AND UNIVERSITY OF BALTIMORE COACH RICHIE MEADE

ON BEING ASKED TO LEAD THE UB LACROSSE PROGRAM:

I was at North Carolina, and I remember [UNC head coach] Willie Scroggs said to me, "You know, the UB job is open."

Like everybody else, I said, "UMBC?" He said, "No, University of Baltimore." So I had come from Nassau Community College to Carolina, and I was just getting my master's in the parks and recreation program at UNC. I had moved my stuff in, and they asked me to come up there and interview and to coach lacrosse and teach in what they called their Leisure Studies program. I'm twenty-three years old at the time.

So all the stars aligned, and I went up there and I said, "You mean to tell me if I coach this team you'll let me have sweatshirts?" That's how young I was. I didn't even care if they paid me. It was a great opportunity for me to work with some really great people. Frank Szymanski was the athletic director at the time; he really helped me develop as a coach and as a person.

THE PRIDE OF THE OLD LINE STATE

ON BEATING PREAKNESS TRAFFIC AND THEN MARYLAND IN 1980:
The first year I was there, we played Towson, Loyola and NC State, who had
.a team at the time. We even beat Maryland in 1980.

It was incredible; we're getting ready to play. We'd lost to Loyola by a
goal the week before. We're going to leave UB at 10:00 a.m. in the morning
to drive down to College Park in our vans, and nobody tells me it's the day
of the Preakness. I live in Cockeysville. I'm driving down, and I get off on
Northern Parkway. I think, "What the heck's going on?" I get to UB, and
one of my assistant coaches said, "It's the Preakness." I said, "Were any of
you guys going to tell me that?"

We get down to Maryland, and we forgot the balls. So I feel like a little
kid. Dino [Mattessich] is the assistant at Maryland. I said, "Hey Dino, we
forgot the lacrosse balls." He kind of laughs at me, hands me a red bag full
of a dozen balls and we're warming up before the game, and I'm thinking to
myself, "Man, this going to be something like 29-3."

It was one of those days. We had a kid named Eddie Novak that played
in goal who was unbelievable that day. We ended up going in at halftime
losing, 5–3. I felt like it should have been 100–3. They just didn't knock us
out. We came back in the third quarter. They didn't score, and we shot 5–5.
So it's 8–5 going into the fourth quarter. We just held the ball for as long as
we could and ended up winning.

That was 1980. The bad news was that we had to play them again the
next year. That didn't go as well.

ON THE COMMITMENT OF A UB LACROSSE PLAYER:
UB is something I'm really glad I did and something that really shaped me
as a coach. You had to use your ingenuity; you had to be resourceful, and
recruiting was so different back then. You'd have to take a group and check
them out and get them to play pretty much right away.

It took a lot of dedication to play lacrosse, especially if you were from
Maryland and you weren't living at UB and were a commuter. The guys
that lived downtown had to get on a van every day up to Rogers Avenue to
practice and drive back home. Those guys were pretty tough.

We had only juniors and seniors [UB was an upperclassmen-only
university at the time]; it was just so much different. At the time, we had
three row houses on St. Paul Street as housing. Obviously, it was a commuter
school, and the athletes would live in these houses and for our guys at UB.
I'm still in touch with several of them.

The first game we ever played was against Princeton, my first game, and we ended up beating Princeton, 8–6. Probably the ugliest lacrosse game ever played.

In 1982, we went 11-2. We lost to Hofstra early in the year and then we won nine or ten straight games, and then we lost to Carolina and they were number one in the country. For our last game [of the program], we played Jack Emmer, and I've never let him forget this. We're playing Washington and Lee, and we just steamrolled them. We came out so emotional and so committed that we went up 10–3 at halftime. They ended up coming back, but we held on. So during my time there we were fortunate, we won our first game and we won our last game and we won a few in between. Over the course of those four years, we wound up beating Loyola, Maryland, Towson, NC State…we did okay.

I really appreciate the UB piece of my career because those players were great kids and they still are. When I got down here, I talked to several of them and said, "Hey look, Furman is a new program with no alumni, and you guys are alumni with no program [laughing]." They're doing really well.

CHESAPEAKE BAYHAWKS

The Chesapeake Bayhawks are a member team of Major League Lacrosse (MLL). The league was founded in 1998 by Jake Steinfeld—the high-profile "Body by Jake" fitness expert—and David Morrow. Morrow is well known to lacrosse fans. He won the Schmeisser Award as the Defensive Player of the Year in 1992 and 1993 under Head Coach Bill Tierney while at Princeton. In 1992, the Tigers captured the national championship, and in 1993, Morrow earned the Lieutenant Raymond Enners Award as the USILA's national player of the year.

Along with his father, Morrow founded Warrior Sports, premised on the usage of titanium in the manufacture of lacrosse sticks that were lighter and stronger than any available metal stick shafts on the market. In a connection to Maryland, Morrow would travel east from his native Michigan to play club lacrosse for the Mount Washington Lacrosse Club after his college years. His continued play there helped him make the 1994 and 1998 U.S. teams. Both teams won gold medals at the World Championships, the first in Manchester, England, and the second in Baltimore. Morrow was voted to the All-World team for the 1998 tournament.

The MLL originally had two divisions. The American Division included member teams Boston, Bridgeport and Long Island. The National Division included New Jersey, Rochester and Baltimore. Those six composed the league lineup from 2001 to 2005.

For the league's first three years, its championship game echoed one of the lacrosse world's traditional debates. Which region has better lacrosse

talent: Baltimore or Long Island? The Bayhawks and Lizards faced each other in the 2001, 2002 and 2003 title games. Baltimore captured the middle frame of the three-game set, winning the 2002 championship. Long Island temporarily had the last word on the debate when it took the 2003 championship, 15–14, at Villanova Stadium.

The Bridgeport Barrage relocated to Philadelphia prior to the start of the 2004 season and won three of the next four league titles, with the Bayhawks interceding to claim the 2005 title. The 2005 Bayhawks' ensemble is considered by many as the best collection of players in the history of the sport. It included former Syracuse stars Gary Gait and Tom Marechek. Gait scored six goals in the final, was the team's player-coach and was also named the league's MVP at the graying sports age of thirty-eight.

Marechek is a member of the U.S., Canadian, National Lacrosse League (NLL) and NCAA Halls of Fame. In 2005, at age thirty-seven, he scored thirty-three goals in just twelve games. Both Gait and Marechek are known for their stick wizardry. Marechek's behind-the-back goals were hallmarks of a highlight-filled career. He is currently the boys' varsity head coach at Friends School of Baltimore.

The team was renamed the Washington Bayhawks in 2007 when they came under new ownership and played their home games at Georgetown. In 2008, they were hosted by George Mason in Fairfax, Virginia. In 2008, as the looming recession began to take definitive form, four teams shuttered their operations, and the remaining six narrowed into one conference. The same year, the regionally nomadic Bayhawks settled in at their current home, one of lacrosse's most famous: Navy–Marine Corps Memorial Stadium in Annapolis.

In 2010, new ownership, Brendan Kelly's Hometown Lacrosse LLC, acquired the team, and its name was changed to the current Chesapeake Bayhawks to better reflect both their new locale in Annapolis and a fan base centered in a region rather than a single city. Kelly was part of Salisbury's 1995 national championship team after playing at Anne Arundel Community College.

With Kelly stepping in mid-year as head coach, the team finished the 2010 MLL with a 6-6 mark and made its first return to MLL's Championship Weekend since the 2005 campaign. The Bayhawks eliminated Boston, 13–9, in the semifinals and won the championship against their archrival Long Island Lizards with another 13–9 victory. It was the third championship in their history.

In 2011, the Bayhawks bowed out in the semis in Annapolis. That matchup, played as Hurricane Irene bore down on the region on August

Calvert Hall and Maryland graduate Jeff Reynolds is now a midfielder for the Bayhawks. *Chesapeake Bayhawks.*

27, resulted in a 14–13 Boston Cannons victory. Max Quinzani completed a hat trick with just over a second left in the game for the win. The Cannons captured the championship on the twenty-eighth under sunny skies, with Towson's Calvert Hall alumnus Kevin Buchanan providing the game-winner in a 10–9 victory.

In 2012, Kelly moved down from the top spot to the front office, and former Loyola and Maryland coach Dave Cottle moved from assistant to head coach. The 2012 team finished the regular season at 10-4, defeated Boston, 16–10, in the semifinals and secured its fourth MLL championship with a 16–6 win over the increasingly star-crossed Denver Outlaws.

The Bayhawks returned to the finals in 2013, and on a flawless August day at Chester, Pennsylvania's PPL Park, they bested the first-year Charlotte Hounds, 10–9. It was their fifth crown and third title in four years, and it affirmed their place as the most successful franchise in league history. In 2014, the 'hawks posted a 5-9 record, and in 2015 they went 6-8, each year missing the postseason. If history is any indicator, the Bayhawks are due back in the thick of the MLL race in 2016.

OVERTIME: HALL OF FAMER AND 2005 BALTIMORE BAYHAWK TOM MARECHEK

Tom Marechek needs no introduction to lacrosse fans. The native Canadian has excelled at every aspect of his career and in retirement from active play. He makes his home in Maryland and leads the Friends School of Baltimore lacrosse team in the MIAA-B. He shared his thoughts on playing for the 2005 Baltimore Bayhawks and coaching at the Friends School.

ON THE 2005 BAYHAWKS TEAM:
The 2005 team was special, obviously. Gary Gait was a player coach, and he was getting older, but he decided to play attack. It was kind of funny having him play attack with me. That was the first time ever. He was always a middie with his brother, Paul, obviously.

So Gary's on attack and here's this young Mike Powell [Syracuse, four-time first-team All-American], who came out of Syracuse and joined us on the attack unit, and we had a great unit. It was just fun. We knew each other pretty well, and that ball was moving around every which way.

ON THE MIDFIELD LINE:
We had Mark Frye [Loyola, All-American] on midfield; we had Jeff Sonke [UNC, All-American] and Josh Simms [Princeton, All-American & Annapolis native]. That's probably the best middie line you'll find anywhere. Our middies were just all horses. They could run up and down the field, and it was a special year.

We didn't practice much together as opposed to college, where we're together every single day. We'd practice once a week, on a Friday night before our games or sometimes on a Wednesday. That was the coolest thing about it—we actually gelled quicker than most teams.

The chemistry was there, and we had fun and we liked each other on and off the field. We were lucky. We did have a lot of returnees that played together for the last few years. That helped. With the addition of Brodie Merrill [Georgetown, All-American] right out of college and with Shawn Nadelen [Hopkins] and Casey Connor [Maryland, All-American] on defense and Trevor Tierney [Princeton, All-American] in goal.

ON TRANSITIONING FROM PLAYING TO COACHING:
Right now, I obviously enjoy coaching. My biggest thrill these days is coaching at Friends School; that's my number one. I like coaching and

directing kids throughout the country with my All-Pro Lacrosse Camps. I've had my lacrosse All-Pro team since about 1995.

The love for the game is still there. I'm at my camps 24/7. I do a lot of instructing. Between that and coaching, that's my true love right now. The playing career was great—playing all those years with the Philadelphia Wings, Baltimore Bayhawks, Team Toyota, Syracuse…growing up playing in Victoria. It was all great. I miss it, but it's a new chapter in my life.

On the benefits of playing other sports as a young athlete:
I started in 2011 at Friends, and I've been there ever since. Right away the thing that stood out to me in Maryland was the amount of the lacrosse kids play these days. I always say until their junior year, I think you should be at least a two-sport athlete, maybe three. Finally, around your junior year, you should pick just one and concentrate on it. It doesn't make you bad to play all three sports all the way through high school. It's going to make you better. We played box lacrosse, we had our season and we moved on to other sports. My soccer playing years made me a better lacrosse player. It's using different muscle groups, it's a different sport and it's going to help your lacrosse career.

CLUB LACROSSE

The earliest days of lacrosse in the East were marked by the predominance of a handful of club teams. In Brooklyn, it was the Crescent Club, and in Maryland, initially, it was the Baltimore Athletic Club. That club was gradually supplanted in prominence by the Mount Washington Lacrosse Club (MWLC).

The MWLC is based in its namesake neighborhood in northern Baltimore City. It has an unparalleled history of success and longevity in the sport at the club level. At points in its history, it's been the dominant team of both the collegiate and club ranks and for decades was a regular opponent on the schedules of top college teams. The team is referred to alternately as the Wolfpack or the Mounties.

The roots of the broader club—the Mount Washington Athletic Club—date back to the mid-1870s. Mount Washington established itself in a physical building in 1903 through the merger of the facilities of two area cricket teams. Former Hopkins coach and player Bill Schmeisser was instrumental in the lacrosse club's founding.

Per available information from the lacrosse club, it was formed in 1904 and first engaged Johns Hopkins in a lacrosse game that same year. In 1906, the club retired other sports from its lineup of offerings to focus on lacrosse.

The team is currently a member of the American Lacrosse League (ALL), and prior to the founding of Major League Lacrosse, many of the top players would compete for or against the club to stay in game form for World Championships. The club's lineup of players represented the United

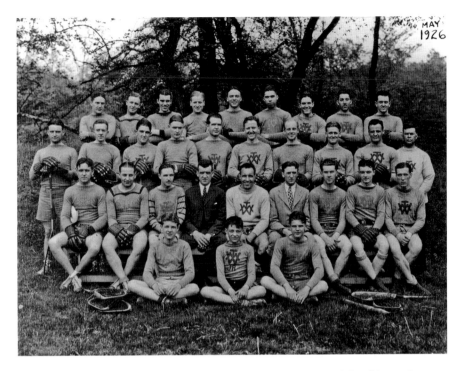

The Mount Washington Lacrosse Club, shown here in 1926, is one of the oldest and most successful clubs in the sport's history. *National Lacrosse Hall of Fame.*

States in the initial World Lacrosse Championships in 1967. They won the competition by defeating teams from England, Canada and Australia. One of the few teams for which the MWLC was no match in the 1960s was "Bildy" Bilderback's Naval Academy teams. The team continues to excel within the ranks of the ALL today and adds to its lineup of some of the game's greatest players.

To the south of Baltimore, a lacrosse club existed in 1932 for the Bethlehem Steel Company based at Sparrows Point. Other men's level club teams of recent decades include the Baltimore Lacrosse Club (BLC) with roots extending back to the 1950s. The club still exists today and is a fellow member along with the MWLC of the American Lacrosse League.

FCA (Fellowship of Christian Athletes) Lacrosse sponsors a men's team that had an abrupt club start in July 1992, when it quickly assembled a group for the famous Vail Shootout tournament. Under the direction of Frank Kelly and his wife, Gayle, they booked twenty flights to Colorado, not knowing who would show. The seats gradually filled, and the team made a run to the championship game before falling. The unexpected

march included a victory over a powerful Green Turtle squad en route to the final.

The FCA Lacrosse men's team currently competes in the Maryland Masters Lacrosse League (MMLL). Founded in 1998, the league presently has a lineup of thirty teams. Originally based on a lineup of just four teams, the MMLL now includes more than seven hundred players.

Youth Clubs

The youth level has seen an explosion of club teams in last decade. A geographic sampling of clubs includes the Baltimore Lacrosse Club's Crabs, Howard County's Maryland Roughriders, Frederick County's Team Maryland and Washington County's Lionheart Lacrosse. Baltimore County's FCA Lacrosse program has been the starting point for a nationwide network of teams and produced the 2015 U15 national champions.

Charm City Youth Lacrosse, with its chairman Pace Kessenich, is dedicated to starting a full-scale league within the city and has begun to send teams to participate in club tournaments.

THE HIGH SCHOOL PROGRAMS

As referenced earlier, Johns Hopkins had a considerable hand in the growth of high school lacrosse in Baltimore, as it actively encouraged nearby schools to take up the sport. The expansion from several city schools grew within Baltimore and then beyond. It did not remain a private school sport in the city, but extensive growth in its public schools developed more slowly.

"City [Baltimore City College High School] and Poly [Baltimore Polytechnic Institute] were the two big public high schools back then, they picked it up in the early 1920s," said Joe Finn of the Lacrosse Museum and National Hall of Fame.

The Maryland Scholastic Association (MSA) was formed around the same time in 1919 and was composed of a mixture of public and private schools, with its hub in Baltimore but extending out into the surrounding counties. It was based on relative strengths of schools with "A" the highest classification. The 1967 "A" division, to provide an example, included Boys' Latin, Calvert Hall, City, Friends, Gilman, Edmonson High School, Poly, Severn and St. Paul's.

As a historical aside, during that era, as with today, some of Maryland's teams would play top competition in other states. The process for finding an opponent was slightly more involved than an exchanged e-mail. If you looked at the 1966 *Lacrosse Guide*, you would see an ad for the *National Directory of High School Coaches*. It spanned 288 pages and contained sixty thousand coaches for all sports. The ad indicated that the book included

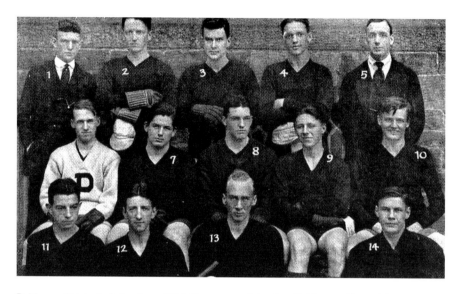

Baltimore Polytechnic Institute ("Poly") was one of the first Baltimore City public schools to take up the sport and is shown in this 1922 team photo. *Lacrosse Guide.*

addresses but not phone numbers. It was an early, printed precursor to a search engine.

The MSA was dissolved in 1993–94, with public schools joining the existing Maryland Public Secondary Schools Athletic Association (MPSSAA) and private schools boys' lacrosse programs in the Baltimore region joining the newly formed Maryland Interscholastic Athletic Association (MIAA).

The MPSSAA has leagues within it, such as the Howard County League, that segment its members geographically. Competing teams are also grouped according to size. The MIAA now has representatives in eight Maryland counties and partitions its league into A, B and C levels based on size and past performance.

Given the desire for parity, there is movement among the levels that varies by sport, although in recent years they have remained relatively static at the upper levels in lacrosse. The MIAA groupings include some well-known lacrosse programs. As of 2015 the league was aligned as follows:

- *MIAA-A*—Archbishop Spalding, Boys' Latin, Calvert Hall College High School, Gilman School, Loyola Blakefield, McDonogh School, Mount Saint Joseph, Severn School, St. Paul's School and St. Mary's High School

- *MIAA-B*—Annapolis Area Christian School, Archbishop Curley, Friends School, Gerstell Academy, Glenelg Country School, John Carroll School, Park School, Saints Peter & Paul High School, St. John's Catholic Prep and St. Vincent Pallotti

- *MIAA-C*—Beth Tfiloh School, Chapelgate Christian Academy, Concordia Prep (formerly Baltimore Lutheran School), Cristo Rey Jesuit, Indian Creek School, Key School and Mount Carmel

Some notables among hundreds within the histories of current MIAA programs include McDonogh capturing the MSA-A with a 7-1 mark in 1932 and Severn School capturing the 1965 MSA-A championship over Boys' Latin by a score of 9–6. That year, Severn was led by coach Fred Hopkins, and included among stiff competition were games against Hopkins's freshman team (a 9–5 victory) and Maryland's freshman (10–6 loss). The win kept Boys' Latin from a 1964–66 sweep of titles.

In 1957, St. Paul's School defeated Sewanaka High School of Long Island, 9–2, to snap the latter's ninety-one-game winning streak. Calvert Hall, under future Maryland head coach Dick Edell, captured the 1971

Both Boys' Latin and the Severn School have long, successful histories in lacrosse in Maryland at the high school level. *Mary Carole Curran.*

and 1973 MSA-A titles and annually contends for a top spot in the league. More recently, in 2003 and 2012, the Cardinals also captured titles. Gilman captured the MIAA-A title in 2009 and 2011.

Loyola Blakefield captured an MSA-A title in 1986, to cite one of many. It claimed the 2013 title with a stunning win over a previously undefeated Boys' Latin squad.

In more recent years, Carroll County's Gerstell Academy loudly announced its entry into the MIAA-C ranks by capturing the league title in 2012 in its first season. It followed it up with a repeat championship in 2013. In 2015, St. Mary's High School in Annapolis captured the MIAA-A title.

Several Maryland private schools based near Washington presently compete in lacrosse in the Interstate Athletic Conference (IAC), including Bullis School, Landon School and Georgetown Prep. Bishop McNamara, Good Counsel, DeMatha and St. Mary's Ryken are part of the Washington Catholic League. Rob Bordley, the legendary Landon School head coach, surpassed the six-hundred-win mark at the Bethesda school in 2015 and continues to coach.

Older private schools in northern Maryland with boys' programs include West Nottingham Academy (WNA) and, as a recent addition, North East Maryland's Tome School. The Tome Hill School for Boys (now the coed Tome School) had a varsity team in the 1930s that for two years was led by Hall of Famer John W. Boucher. The school's grounds were perched on a hill above the town of Port Deposit overlooking the Susquehanna River. A *1933 Lacrosse Guide* schedule shows the team facing McDonogh, Friends and Poly, although W. Wilson Wingate noted in the guide that it was not a member of the MSA in 1932. During World War II, its grounds were pressed into service as the Bainbridge Naval Training Center. The Tome School Titans, led by coach David Cain, fielded their first varsity team in eighty years in 2015, launched auspiciously with twenty-two players and a 5-2 record.

Western Nottingham Academy was founded in 1744 and is the nation's oldest boarding school, with a mixture of resident and day students on campus. Lacrosse was introduced there as an intramural activity in the spring of 1981. It became a varsity sport in 1982–83 and has helped to sustain and grow the popularity of the game in Cecil County.

Turning to the public schools, Howard High School and Baltimore County's Hereford High School, as well as a host of other schools, compete at an especially high level.

The *Baltimore Sun's* Matt Owings was on hand for the 2014 4A/3A championship between Howard and South River and said presciently, "The

West Nottingham Academy's lacrosse team began in 1981 as an intramural sport at the school and in 1982–83 gained varsity status. *West Nottingham Academy.*

Seahawks were too experienced for the Lions, and despite Howard's Notre Dame–bound face-off specialist John Travisano's near perfection on draws, the Lions dropped their first bid for a state championship, 9–6. They surely have a return visit in their future." They did, and the next year they captured their first lacrosse state championship.

Lacrosse is now played in roughly 170 schools in Maryland. Rather than list every program and its highlights—that would be decade-long effort—included here are longer descriptions of two schools, Boys' Latin and Western Maryland's St. James. The former highlights arguably the state's most accomplished program, and the latter provides a glimpse of a program playing outside the better-known Baltimore and Washington areas.

BOYS' LATIN SCHOOL OF MARYLAND
(BALTIMORE, MARYLAND)

The Boys' Latin's storied lacrosse program first fielded an official varsity team in 1929 under Head Coach Dow Strader, the first of three coaches in the program's first three years. In its fourth year, Boys' Latin captured its first championship, in 1932, with an 11-2 mark. That was followed quickly by a title in 1934 behind an 11-1-1 record.

Lean championship years ensued, although there was no lack of victories or winning seasons. The 1940s included eight winning campaigns, four nine-plus win seasons and championship appearances five times. The best year of the decade was a 13-1 record in 1947.

The Lakers broke through finally in 1964 to claim the MSA-A title. As with the 1930s pattern, this was followed by a championship two

Shack Stanwick starred at Boys' Latin before joining the Johns Hopkins Blue Jays. *Mary Carole Curran.*

years later in 1966. After another—and, thankfully for the Lakers' faithful, shorter—absence of championships, the team took two crowns in the 1980s, winning the 1985 and 1988 MSA titles.

The remaining championships came in the MIAA era, with titles in 1997, 2002, 2006 and most recently in 2014. The 2002 and 2006 teams each won an astounding twenty-plus games, with 2002's ledger at 20-2 and 2006 at 21-0. The 2013 team went 19-1, falling in the MIAA-A championship to the Loyola Blakefield Dons, 10–9.

In that game, reported on by the *Baltimore Sun*'s Glenn Graham, Loyola's Devin McNamara notched the difference-maker with less than two minutes left in the game. The game was played before a reported crowd

of 6,271 fans. "It can be argued the Dons made the most improbable run to the championship game in league history. After a loss to Calvert Hall in the regular-season finale, they were on the outside of the playoff picture and many seniors were sitting in the locker room telling each other how much they enjoyed playing together," wrote Graham.

The Lakers returned to the final in 2014 and closed out the season with an MIAA-A championship win over St. Paul's School at Towson's Johnny Unitas Stadium. Head Coach Bob Shriver retired in 2015 at the age of sixty-three and a record of 506-138. He won six league championships.

In his playing days, Shriver attended first Boys' Latin and then went on to Washington College in Chestertown. He was twice named a captain of the Shoremen and also an All-American. Shriver returned to Boys' Latin, initially as an assistant coach and science teacher. He became the head coach in 1979, leading the team to a championship. Shriver never had a losing season while head coach of the Lakers and is one of the most accomplished coaches in the history of the sport.

St. James School (St. James Maryland)

Long woven into the fabric of Maryland life, lacrosse holds a still longer history in parts of upstate New York and Canada. Its roots are equally deep in New England, where the sport has developed an especially strong association with the many prep schools that dot its landscape. Phillips Exeter and Deerfield Academies are two of a number of private schools with strong lacrosse (and accompanying hockey) programs that regularly turn out top players. With the arrival of each spring, their campuses echo with shouts, whistles and the metallic collision of sticks resonating from the lacrosse field. The mix of sounds is as inevitable as mud season and the ensuing bloom.

St. James School, located roughly six miles to the southeast of Hagerstown in the unincorporated town of St. James, looks the part of a prep school uprooted from the foothills of the Berkshires and dropped in Maryland. Its history extends back to 1842, when it was founded as the College of St. James. College Road, now a misnomer, holds much of the hundred-acre-plus St. James campus in the elbow of a sharp turn. Pulling off to enter through its main entrance, Turner Field sits to the right of the road and is home to a handful of the school's teams, including the boys' lacrosse squad.

Continuing straight on the road leads to a cluster of red brick Georgian buildings that contribute to the signature appearance of St. James.

The Saints' lacrosse program initially began in 1969 under Athletic Director Bob Woodruff. The team currently plays in both the Interscholastic-Parochial School League (IPSL) and the Middle Atlantic Conference (MAC). The IPSL includes teams near at hand for the Saints, including a perennially talented St. John's Catholic Prep (also an MIAA member) program in Frederick and the St. Maria Goretti High School Gaels in Hagerstown. The MAC is composed of predominantly metro D.C. teams.

In 2011, Steve Lachut, a former captain and defenseman at Buffalo's Medaille College, took over as the head coach at St. James. Asked whether western Maryland lacrosse has a style of play that was discernible from that of other places, Lachut said, "I think it tends to be more set-play oriented, and physical, than what I was used to." He added, "I grew up in Buffalo, and we were physical but play tended to still flow more freely. As you travel east and south in Maryland, you can expect to see more free-flowing play, a little more of a finesse-centered game."

For its relatively small size—the entire coed student body for grades 8–12 hovers around 225—St. James draws large numbers out to the lacrosse field each spring. "We usually have fifty to sixty boys come out for lacrosse, depending on the year," said Lachut. That fills out a varsity and junior varsity roster, and in recent years, when the numbers have supported it, the school has added an additional team for younger players.

When prompted for the highlight of his tenure to date, the Saints' head coach didn't hesitate, finding it in the 2014 IPSL championship over St. John's Catholic Prep. After starting the season at just 2-8, the team reversed course, going 7-1 down the stretch and ultimately winning the IPSL championship game against the Vikings.

After taking an early lead in the title game, St. James yielded five straight goals before the close of the first quarter. The Saints then responded and scored four straight of their own to take a 6–5 lead. The two teams traded goals in the final thirty seconds of the first half. Ultimately, it was the Saints' defense that secured the win, including nine saves from goalie Will Smith. "We played stellar defense in the final minutes, right down to the last second, to win 13–12. We used all the lessons we learned on our journey there," said Lachut.

St. James is roughly three-fourths boarding students, and in that regard, it is especially similar to its northern counterparts. One standout who came through the Saints' program in recent years as a boarding student was

St. James School captured the 2014 IPSL championship over St. John's Catholic Prep. *St. James School.*

Kyle Neale of Brooklyn, New York. "I played for a lacrosse team called the Brooklyn Admirals. Since lacrosse isn't all that big in the boroughs other than Manhattan, at the time the Admirals were one of only two teams competing. We were predominantly comprised of minorities from across Brooklyn," said Neale. "However, my true love for lacrosse began to bloom when I left for boarding school. The first school I went to was a junior boarding school in Pomfret, Connecticut, called the Rectory School."

While attending the Rectory School, Neale interviewed at St. James during "swine flu week" in the fall of 2009, when the student body had been temporarily dismissed to stall the disease's spread. "I first thought it would be difficult to get a real feel for the school without the students. However, Father Dunnan [St. James's headmaster] and the admission director made such a positive impression on me it was impossible for me to say no," said Neale. "Those impressions and feelings mixed in with the academics and beautiful red-brick architecture of the school were the key factors that had me sold," he added.

Neale primarily played as an offensive midfielder for St. James and occasionally would face-off for the Saints. In addition to lacrosse, he played

two years of basketball and four years of football before graduating in 2013. The Brooklyn native was a three-time letter winner in lacrosse and a senior captain, and he also won MAC All-Conference and overall MVP honors his final year. He attends Wheaton College in Norton, Massachusetts, and plays midfield for the Lyons.

Asked if the Saints had a defining or characteristic style, Neale's recollection echoes the sentiment of Lachut's words: "St. James didn't emphasize a particular style of play. We didn't necessarily need to run that many set plays. The goal is to put the ball in the back of the net, and our coach trusted us enough to do that."

EPILOGUE

It was the spring of 2012 when I walked to the bleachers that afford the highest vantage point on the upward slope of Chapelgate's Marriottsville campus. The Yellowjackets were hosting Cristo Rey Jesuit, a school with many students from the working-class neighborhoods in east Baltimore.

The Hornets were having a long afternoon. It was their first year in the MIAA, and many of their players looked new or relatively new to the game. Their coach stood poised across the field, wearing a blue cap and directing his players calmly but assuredly from the far sideline. He shouted instructions and direction, but there was no verbal belittling under the guise of coaching. There was patience, specific instruction and steadfast reminders of how to do things right and reminders of what they'd done well.

I knew who the coach was but hadn't met him. It was Matt Hanna, a former standout at midfield for Johns Hopkins and later a Major League Lacrosse All-Star for the Denver Outlaws. I was working on an article about his inexperienced team from the city venturing into the MIAA. It was a daunting league for any lacrosse team to join, let alone a new one from parts of the city where the game was considered a sport for kids from other neighborhoods.

Hanna is from Geneva, New York, and his father, Mike, is the athletic director at Hobart College. The elder Hanna is a veteran and a former accomplished football and lacrosse player and coach. As part of what I came to realize in writing this book, Matt is representative of a unique exchange of families that has occurred for generations between New York and Maryland

Former Hopkins Blue Jay Matt Hanna started the lacrosse team at Baltimore's Cristo Rey Jesuit High School in the early 2010s. *Matt Hanna.*

because of a common love of lacrosse. My former boss, Pat Greene, was part of the same exchange.

I'm sure there are some Baltimoreans on Long Island gradually losing their regional dialect for a stronger one, or in upstate New York phoning home after shoveling to make light of our thin-blooded Maryland winters. Each area is the better for it; certainly I know Maryland is. Hanna—like Goucher head coach and Maryland native Brian Kelly—is a former Turnbull-Reynolds Award winner for exhibiting outstanding leadership and sportsmanship while at Johns Hopkins.

They're now exhibiting them beyond the college midfield stripe. Kelly is leading student-athletes at one of the best colleges in the country. His roster includes one of Hanna's former players, Winfield Hopkins. Hanna has moved on from Cristo Rey to work full time at his nonprofit, Next One Up organization, which, as its mission statement notes, is "transforming the lives of young men in Baltimore City by supporting and advancing their academic, athletic and social development." Along with his wife, Tori (a former lacrosse All-American and national champion at Maryland), they are also raising a young family.

Hanna's work is not high-profile stuff, and there's little time for self-promotion when you're on the phone all day promoting others. Or trying

to keep young student-athletes away from the mistakes that are available at every turn.

Easily what I've enjoyed most about this book is getting to know the people of the lacrosse world. Both those I've had the good fortune to meet, like Dick Watts, or those I've only come to "know" through research, like Maryland's R.V. Truitt.

The game is in a league by itself to watch and often more exciting than baseball, I'll now readily rather than reluctantly admit. But the attributes the sport shapes in its participants and coaches—teamwork, commitment and hard work several among many—are clearly common to players from any region of the country.

Thanks to lacrosse, we're fortunate to have so many of them gathered right here in Maryland.

BIBLIOGRAPHY

BOOKS

Fisher, Donald M. *Lacrosse: A History of the Game*. Baltimore, MD: Johns Hopkins University Press, 2002.

Pietramala, David G., and Neil A. Grauer. *Lacrosse: Technique & Tradition, the Second Edition of the Bob Scott Classic*. Baltimore, MD: Johns Hopkins University Press, 2006.

Weyand, Alexander M., and Milton R. Roberts. *The Lacrosse Story*. Baltimore, MD: H&A Herman, 1965.

PROGRAMS, MAGAZINES AND NEWSPAPERS

The Boys' Latin School of Maryland. *Boys' Latin Lacrosse 2014: "Over 165 Years of Laker Pride and Tradition."* Baltimore, MD, 2015. issuu.com/blpublications.

Eigenbrode, Ryan, and Loyola University Maryland Office of Athletic Communications. *2014 Loyola Greyhound Lacrosse: Patriot League Inaugural Season*. Baltimore: Loyola University Maryland Printing Services, 2014.

BIBLIOGRAPHY

Fitzpatrick, Alexandra, ed. *Slash Magazine, the Official Magazine of Major League Lacrosse, 2013 Championship Weekend.* Boston: Marketing and Public Relations Department of Major League Lacrosse (MLL), 2013.

Larossa, Ernie, and the Johns Hopkins University Athletic Communications Department. *2015 Johns Hopkins Lacrosse Program.* Elmont, NY: University Sports Publications Company Inc., 2015.

Maryland Interscholastic Athletic Association. *PNC MIAA Lacrosse Championships 2014.* Baltimore, MD: self-published, 2014.

Michaud, Stacie, and the United States Naval Academy—Navy Sports Information Office. *2014 Navy Lacrosse.* Elmont, NY: University Sports Publications Company Inc., 2014.

Moran, Nairem, and St. Mary's College of Maryland Athletics Sports Information Office. *St. Mary's College of Maryland Seahawks 2013 Mens' Lacrosse.* St. Mary's, MD, 2013. issuu.com/smcseahawks.

National Collegiate Athletic Association. *NCAA Men's Lacrosse: 2014 Preliminary Rounds.* Lexington, KY: IMG Publications, 2014.

Parks, Maura, Noah Becker and the Frostburg State Athletic Communications Office. *2015 Frostburg State Men's Lacrosse Guide.* Frederick, MD: Tri-State Printing, 2015.

Sakamoto, Ryan, and the Georgetown University Sports Information Office. *2014 Georgetown University Men's Lacrosse Gameday Program.* Design by Old Hat Creative. Annapolis, MD: CPS | Gumpert, 2014.

Spalding's Official Lacrosse Guide with Intercollegiate Playing Rules. New York: American Sports, 1922.

Ticknor, Philip, and the Washington College Athletics Communications Office. *Washington College Shoremen Lacrosse '05: "The Triumph of Tradition."* Chestertown, MD: Kent Printing, 2005.

INDEX

INDEX

INDEX

INDEX

About the Author

Tom Flynn is a longtime freelance journalist and has written extensively on sports. In 2008, he wrote *Baseball in Baltimore*, a photo history of the sport in the city. In 2015, Loyola University Maryland republished his novel, *Venable Park*, set in 1920s Prohibition Baltimore.